Copyright © 2018 by Aaron Pilat
All rights reserved

*No part of this book may be reproduced or used
in any manner without written permission of the copyright
owner except for the use of quotations in a book review.*

For more information or permission requests, write to the owner at
aaron_pilat@hotmail.com

ISBN 978-0-578-42479-8

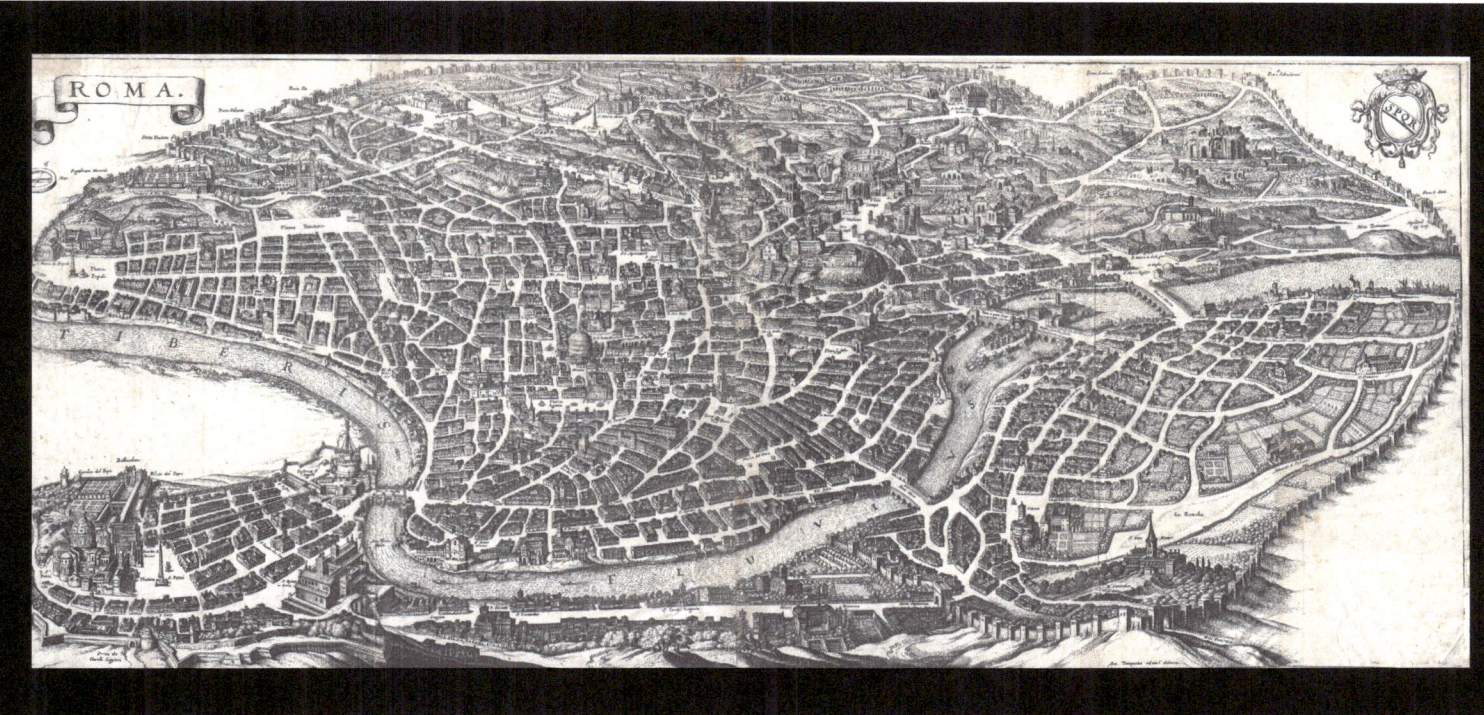

ROME IS A THRIVING CITY OF RUINS.

New and old coexist in harmony due to continued adaptation, preservation, and re-use. The result is a vibrant and flourishing city that is constantly re-inventing itself. The Ancient Roman Basilica of Maxentius, for example, now hosts a summer concert and events series, while the Renaissance structure, Palazzo Altemps, has been transformed into an art gallery.

This project examines how such transformations have been enacted in the physical sense, through the lens of an architect. Over the course of a year spent at the American Academy in Rome, I studied the ways in which key sites of the city have grown and developed over centuries.

The projects selected—historic buildings and urban spaces—reflect the variety of survival and integration tactics employed in a constantly changing urban landscape. Through the documentation and analysis of these sites I have elicited a series of lessons depicted through drawings and diagrams.

For architects, builders, and clients, Rome reminds us that the buildings we design and construct rarely retain their original function throughout their lifespan. To build sustainably, we must create adaptable structures, and more importantly look for ways to give new life to old structures;

Rome shows us how to do this.

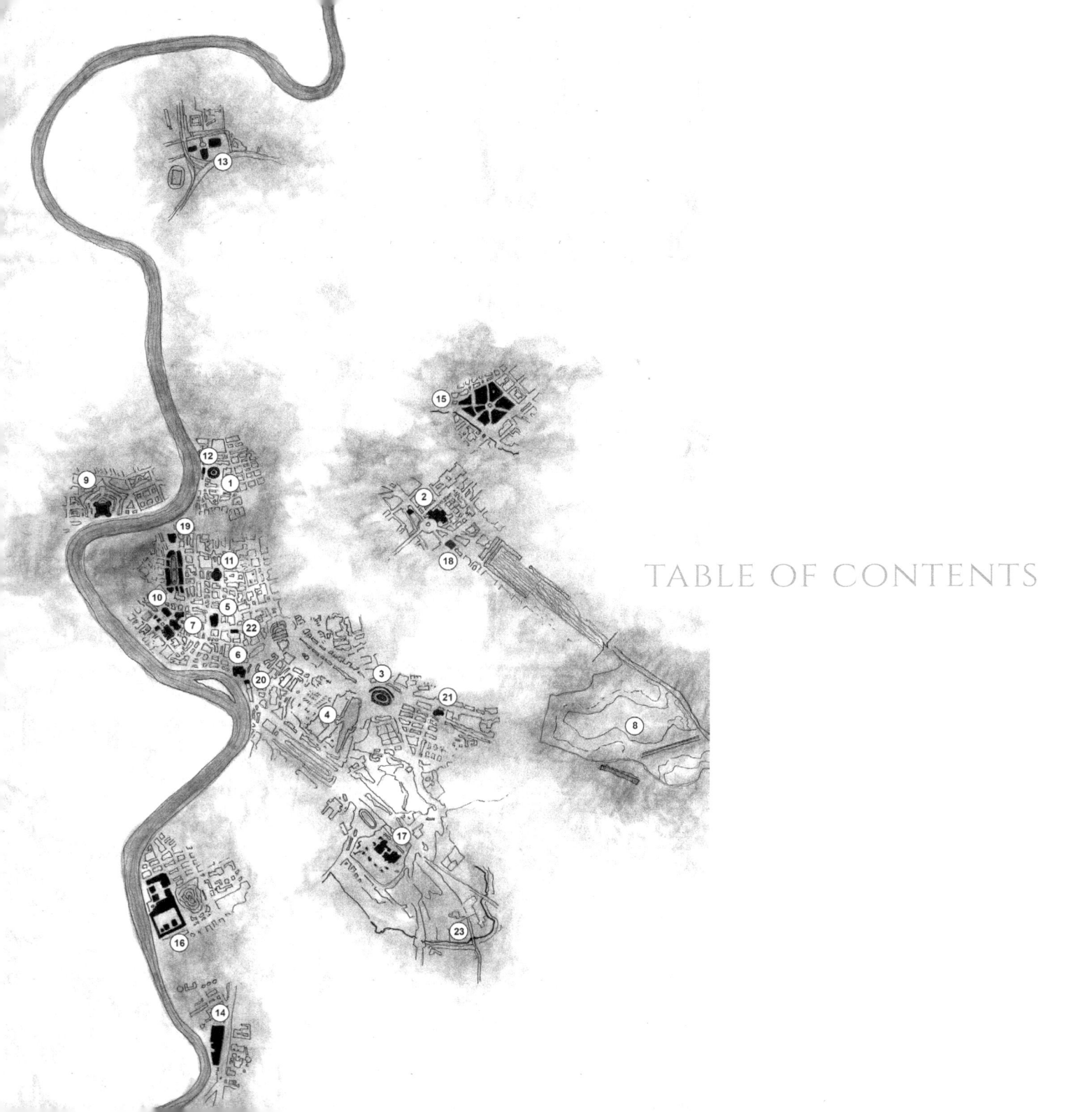

TABLE OF CONTENTS

Part One: Urban Scale Projects

1. Mausoleum of Augustus
2. Diocletian Baths
3. Coliseum
4. Imperial Forums
5. Largo Argentina
6. Theater of Marcellus
7. Theater of Pompeii
8. Centocelle
9. Castel Sant' Angelo
10. Campo de' Fiori & Piazza Navona
11. The Pantheon & Piazza della Rotonda

Part Two: Building Scale Projects

12. Museum of the Ara Pacis
13. Auditorium Parco della Musica
14. Centrale Montemartini
15. Peroni Complex
16. MACRO al Mattatoio
17. Baths of Caracalla
18. Palazzo Massimo alle Terme
19. Palazzo Altemps

Part Three: Detail Scale Projects

20. S. Nicolas / Roman Temples to Juno, Janus & Hope
21. San Clemente
22. Crypta Balbi
23. Museum of the Walls

1. Mausoleum of Augustus
2. Diocletian Baths
3. Coliseum
4. Imperial Forums
5. Largo Argentina
6. Theater of Marcellus
7. Theater of Pompeii
8. Centocelle
9. Castel Sant' Angelo
10. Campo de' Fiori & Piazza Navona
11. The Pantheon & Piazza della Rotonda

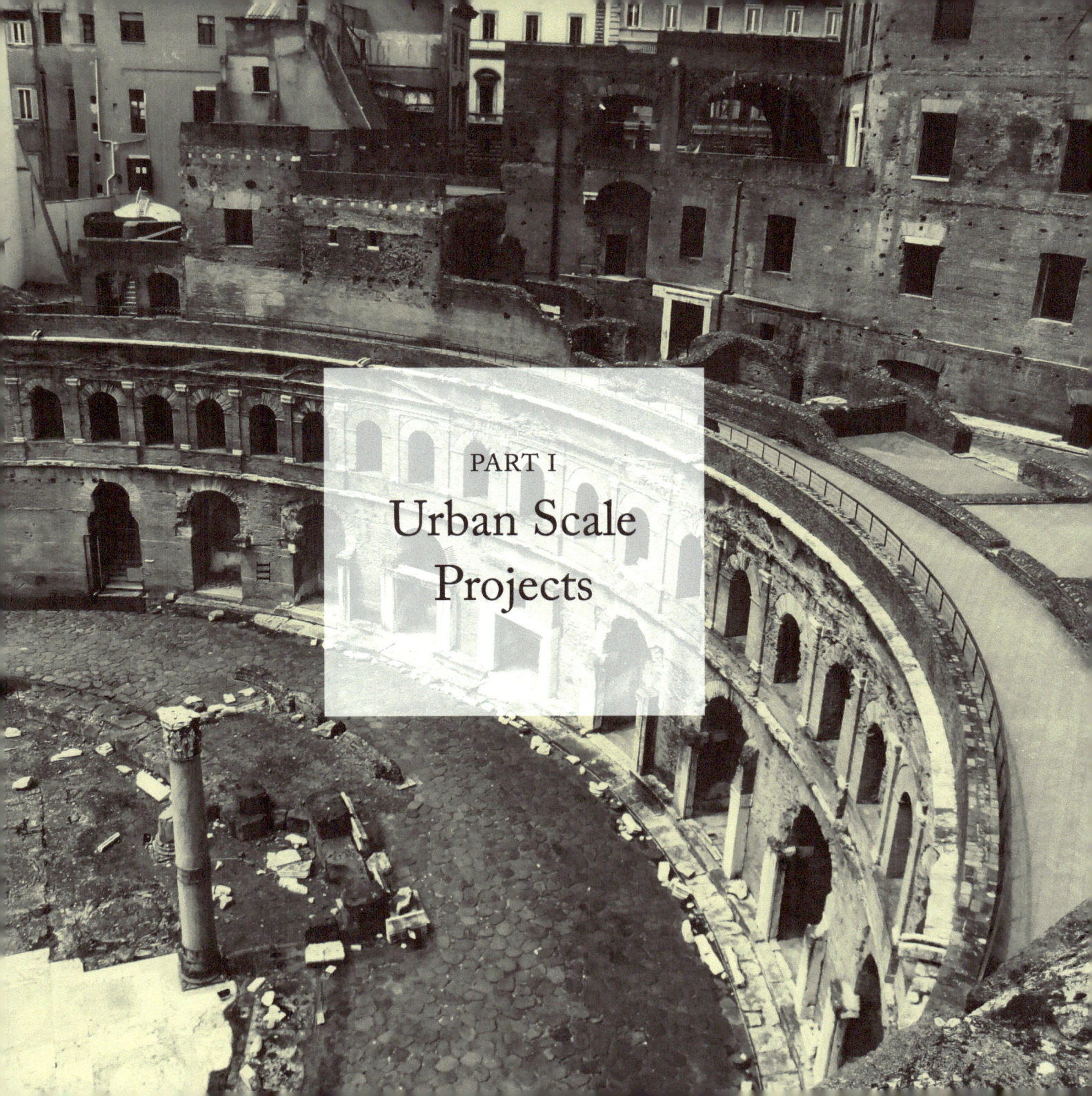

PART I
Urban Scale Projects

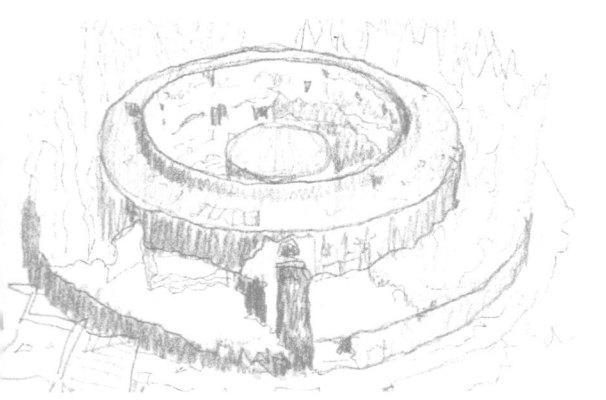

History The Mausoleum of Augustus, Rome's first emperor, is located in the campus martius area of the city center near the Tiber River. As Rome's population declined in the medieval era, the mausoleum fell into ruin and was later used as a fortress. By the 18th century the Mausoleum structure served as the foundation for an arena. In the 19th century the structure supported Rome's main auditorium and concert hall. For the Dictator Benito Mussolini, who had imperial ambitions, the Mausoleum of Rome's first emperor held special significance. In the 1930s he ordered the site to be excavated in order to resurrect the sacred tomb. Fascist buildings, still evident today, were constructed surrounding the Mausoleum as part of the redesign for the area by architect Vittorio Ballo Morpurgo.

28 BCE The Mausoleum of Augustus

Significance The current organization of the site segregates the Mausoleum as a ruin from the surrounding urban fabric and life of the city. The Mausoleum is presented as an object on display. The decaying and overgrown Mausoleum rests within an unattractive, yet accessible circular trench. The sliver of green space surrounding the Mausoleum is cramped, sunken, and uninviting. The ruin at the center of the space no longer serves a contemporary purpose and the surrounding piazza is crowded with parking and bus stops. Thus in the current state, the site and piazza design fails to effectively integrate the ruin into the life of the city. A new design for the piazza promises to better activate and integrate the site.

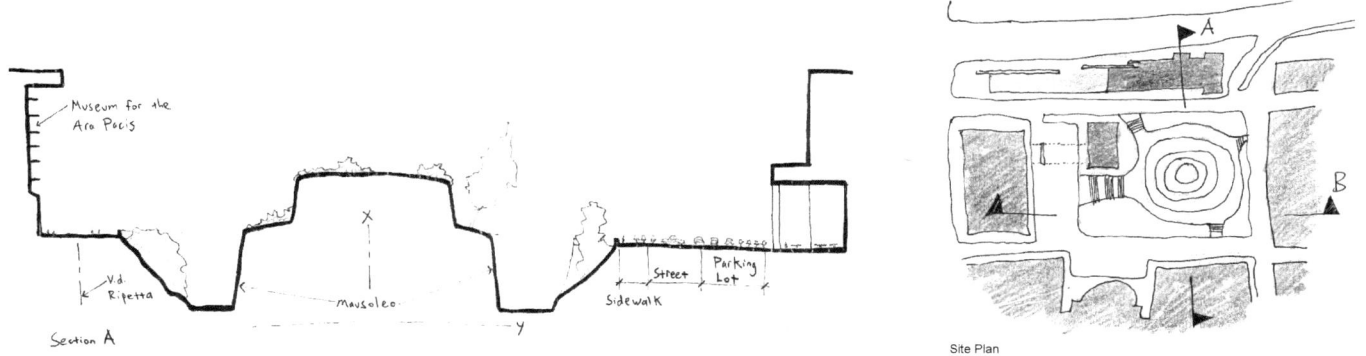

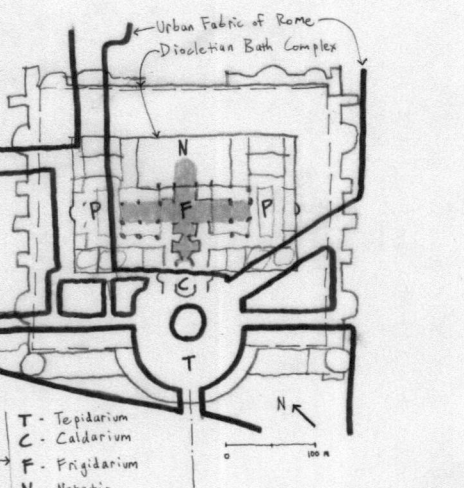

Key
- T - Tepidarium
- C - Caldarium
- F - Frigidarium
- N - Natatio
- P - Palaestra

Bath Complex Plan / Urban Context

Aula Ottagona: Plan

The garden Rotunda is in ruins, but provides an understanding of scale. The Aula Ottagona combines function and preservation. Contemporary functions are concealed.

Ruins on display in the garden from the northeast boundary of the site.

Aula Ottagona: Sections

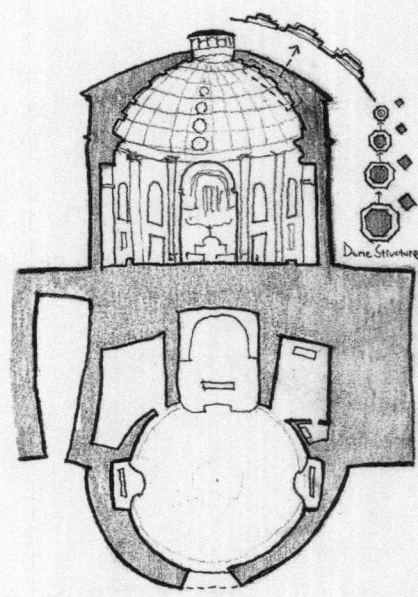

Plan & Section 2
San Bernardo alle Terme

Key Plan

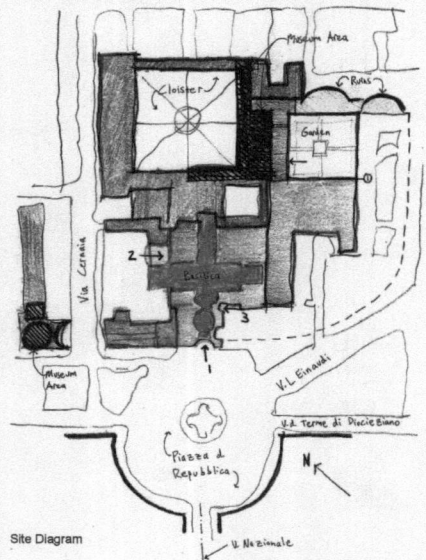

Site Diagram

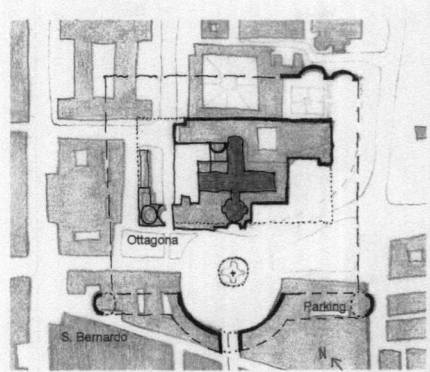

Site Plan (Bath Ruins in Bold)

306 CE The Baths of Diocletian

History The Ancient Roman Baths constructed by Diocletian were the largest thermal bath complex in the entire Roman Empire, serving 3,000 people at a time. The complex is massive; the nucleus of the remaining ruins is centered around the Basilica of Santa Maria degli Angeli and Martiri, the Museuo Nazionale Romano and San Bernardo alle Terme, but the influence of the complex is palpable beyond. Piazza della Repubblica (also known as Piazza Esedra) takes its semi-circular shape from one of the Ancient Bath complex's exedra foundations.

The Baths of Diocletian remained in use until the middle of the 6th century when they were abandoned as the city's population declined. The complex decayed but remained largely unaltered due to its location outside the center of the medieval city. In the early 1500s Bramante and Peruzzi were among the designers who crafted proposals for the re-use of the site. In the mid-sixteenth century, Pope Pius IV commissioned Michelangelo to design a new basilica—the Basilica di Santa Maria degli Angeli e Martiri and an adjacent cloister. In 1702 a Meridian line was installed in the church in order to more accurately locate Easter and to symbolize the dominance of the Christian calendar over the Pagan one. Vanvitelli was called upon to add a new façade and modify the interior of the church in 1749. His façade was removed in the 19th century to reveal the roman ruins beneath. In 1890 the cloister designed by Michelangelo and many of the remaining ruins beyond were transformed into a museum, which displays archaeological works from the baths.

Nearby, the octagonal hall of the Baths was transformed into another church: San Bernardo alle Terme around 1600, with plaster moldings added to the dome in the 19th century. Another octagonal hall near Via Cernaia, was transformed into a planetarium in 1928 and now serves as a museum showcasing ancient sculptures. Via Nazionale, which begins at the base of the Capitoline Hill and culminates in the Piazza della Repubblica, was constructed in 1867.

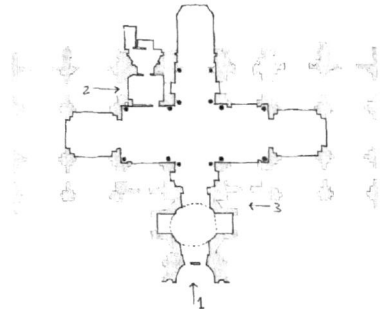

Basilica di Santa Maria degli Angeli Plan & Frigidarium Plan

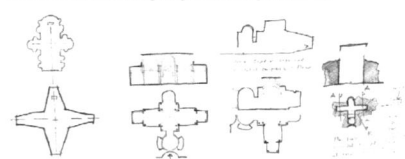

Basilica di Santa Maria degli Angeli Diagrams

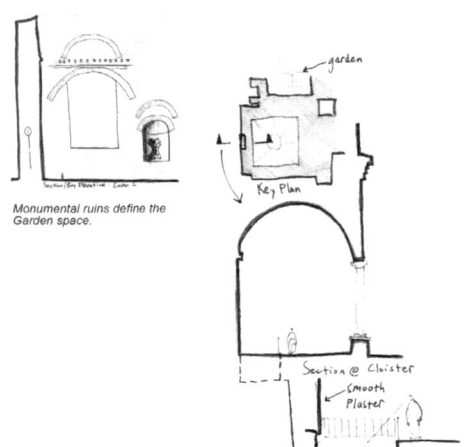

Monumental ruins define the Garden space.

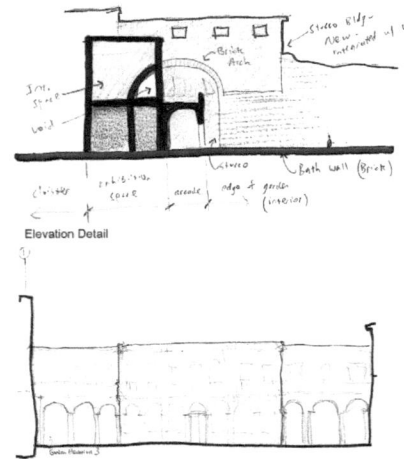

Elevation Detail

Garden Elevation 3

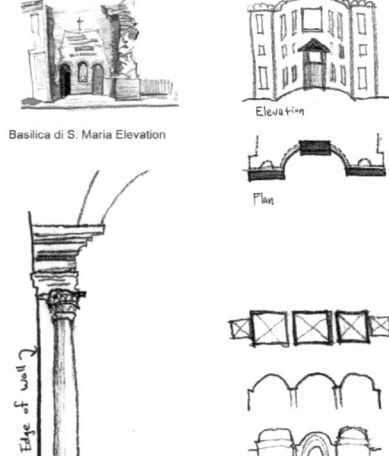

Basilica di S. Maria Elevation

Basilica di Santa Maria degli Angeli: Columns and stark ceiling vaults communicate the scale, form and materials of the ancient baths.

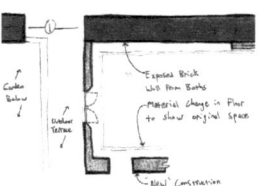

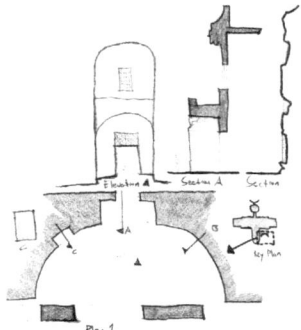

Basilica di Santa Maria degli Angeli
Variations in Scale & Experience.

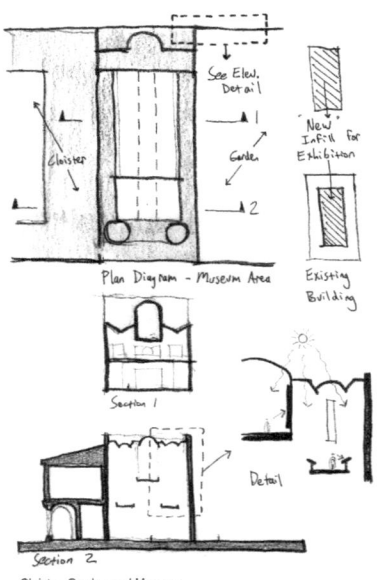

Cloister, Garden and Museum

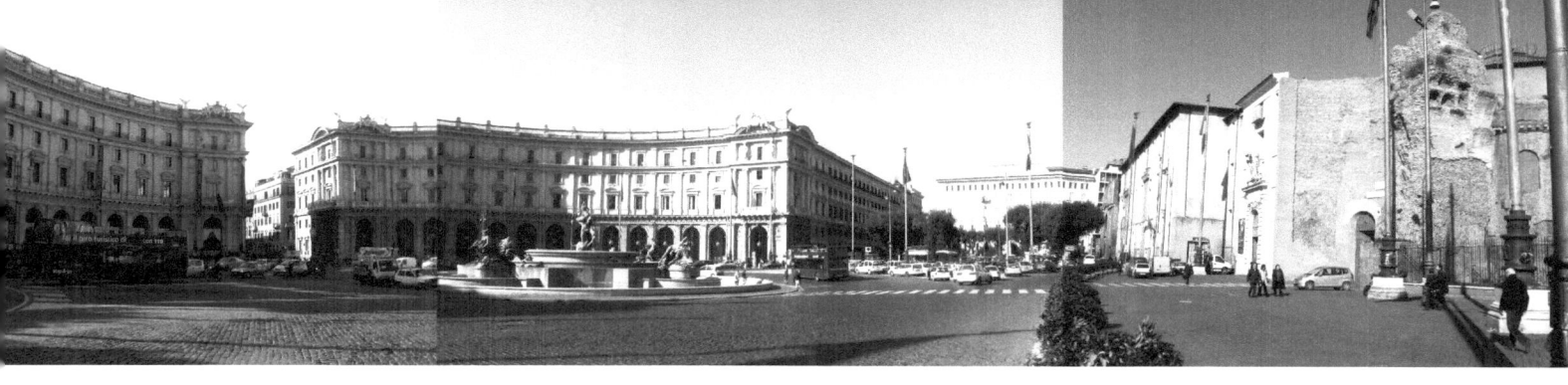

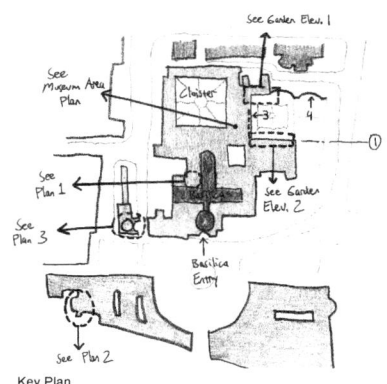

Key Plan

Significance The grand bath complex built by Diocletian has been broken down into parts each of which now has its own history of re-use and adaptation. The Basilica di Santa Maria degli Angeli e Martiri, for example, reflects a blending of structural, functional, and symbolic repurposing. The existing columns and ceiling vaults reveal the original form and scale of the Frigidarium. The grandeur of Ancient Rome has been captured and preserved through Christian reclamation. The three separate entrances reaffirm the locations of the original Tepidarium, Caldarium, and Frigidarium. The removal of Vanvitelli's façade to reveal the Ancient wall beneath reflects the on-going debate over which histories to preserve in the city.

San Bernardo alle Terme combines a functional and structural adaptation with a symbolic reclamation: what was once pagan has been Christianized. At the same time, the original spatial experience of the octagonal-shaped hall has been preserved. The octagonal hall, which was first adapted as Rome's planetarium and now serves as a museum, also retains its form and scale.

The cloister and garden spaces, which form the Museo Nazionale Romano, link a series of spaces together, reflecting a structural and functional adaptation. The new program for the spaces contains exhibition spaces that are successfully embedded within the existing fabric of the bath complex allowing visitors to sense something of the original construction.

80 CE The Coliseum

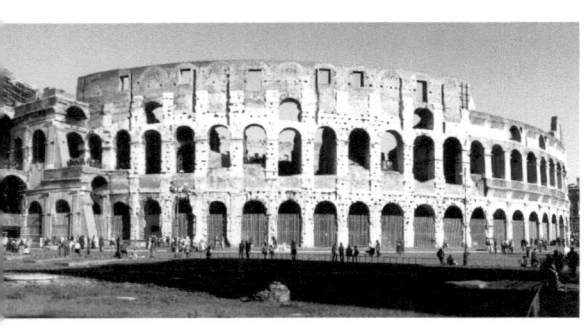

History Under the Emperor Vespasian, construction began on Rome's greatest amphitheater, the Coliseum. With room for 45,000 to 50,000 spectators, it was the largest amphitheater in the Roman world and was used until 523 CE. In the middle ages, the structure housed shops and dwellings. It began to decay during this time, however, due to the pillaging of materials from the site as well as an earthquake, which damaged the structure. In the 18th century, the site was reclaimed by the Catholic Church under Pope Benedict XIV, who initiated the tradition of enacting the stations of the cross at the site. Popes today continue this ritual for thousands of spectators every Good Friday. Structural supports were added to the Coliseum in the mid-nineteenth century. Its primary function today is a tourist attraction; it is the flagship building for those interested in Ancient Rome.

Significance The Coliseum has been preserved rather than truly repurposed. Yet the site is brought to life by the thousands of tourists who visit daily; it serves as an urban icon for the city. The upper levels have been adapted to serve as gallery spaces showcasing exhibitions. Moreover, the partially ruined state allows for visitors to view a cross-section through the structure. A subtle pattern in the ground paving indicates the outlines of the original structure in plan. The building's monumental scale and the relatively open site upon which it sits help to provide opportunities to engage it on multiple levels. One can get views from across the city on foot or speeding by in a car as the location serves as a hinge point for pedestrian and vehicular traffic. Spectacular lighting at night ensures dramatic views at every hour.

SITE 3

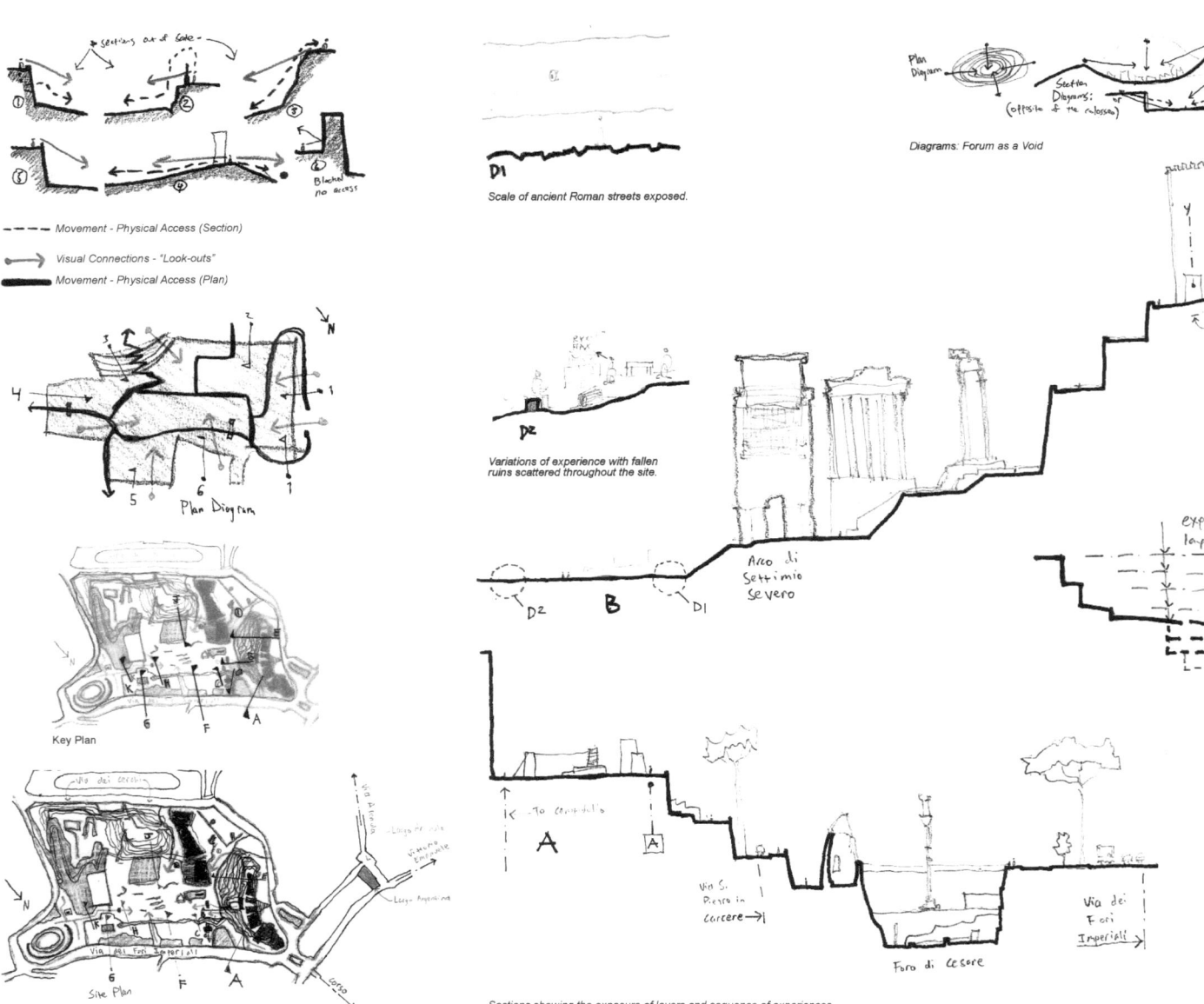

46 BCE – 113 CE Imperial Fora

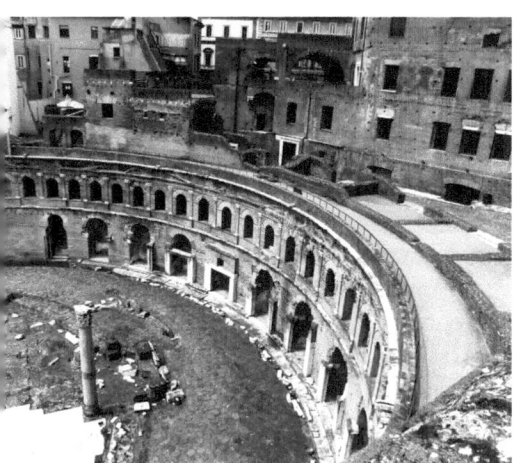

History A series of Roman emperors constructed forum complexes between the Capitoline hill and Coliseum site over a span of roughly 150 years. The fora housed legal, political, economic, and social activities; life in Imperial Rome was centered around the Imperial Fora. As the population declined in the middle ages, the Imperial Fora fell into decline and many of the buildings were pillaged for construction materials. Excavations of the site were started in the 19th century and continue to this day. Under Fascism, the neighborhood that had grown up on top of the Imperial Fora was demolished in order to resurrect the Fora and the vast road connecting the Coliseum and Capitoline, the Via dei Fori Imperiali, was constructed.

Significance The Imperial Fora have been adapted to serve as an archaeological park and tourist destination. The Catholic Church has also reclaimed certain sites, aiding in the preservation of some areas. Today, the Imperial Fora area is an active void in the dense urban center of Rome and thus provides a variety of visual connections and physical experiences. The Fora can be experienced from many different locations and levels within and surrounding the site due to changes in grade. Moreover, the site offers a range of experiences in terms of scale, ranging from the intimate to the grand. Though portions of the Fora remain active archaeological sites, much of the site appears to have been frozen in time after years of construction, demolition, and reconstruction. The ruinous landscape—accessible by day and glowing at night—functions as an icon for the city.

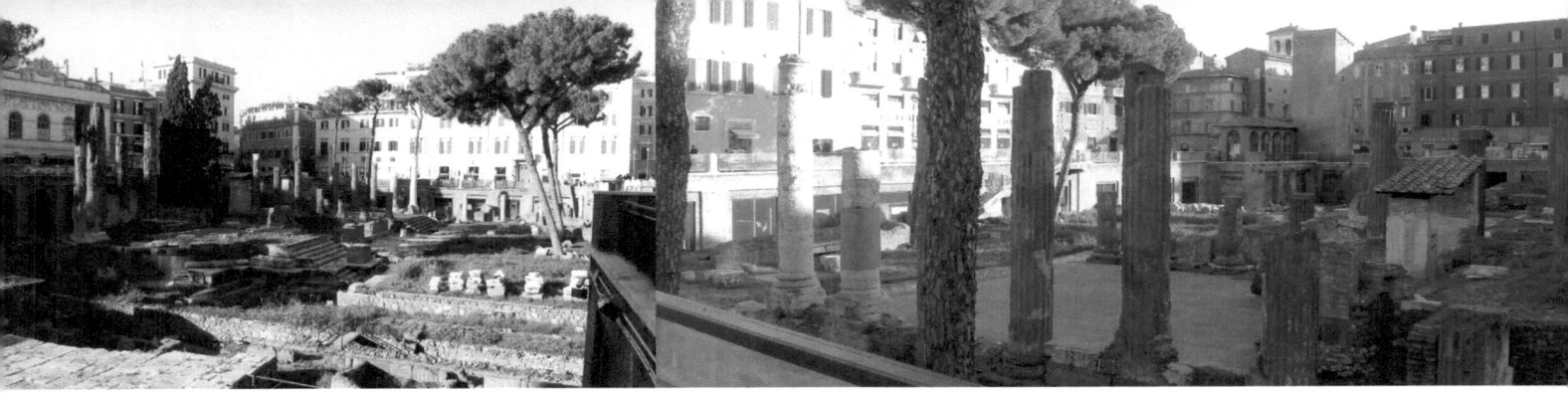

200 BCE – 241 CE Largo Argentina

History Four Republican temples were constructed at Largo Argentina, which is perhaps most famous as the site of Julius Caesar's murder in 44BCE. The Temple of Juturna (temple A) was constructed around 241 CE, but was later subsumed by the medieval construction of the church of San Nicola de Calcarariis. The Temple of Aedes Fortunae Huisce Diei or the Temple of Today's Good Fortune (temple B) was built on the site around 102 BCE. The Temple of Feronia (temple C) the goddess of springs and fountains was built in the early third century BCE. The last temple constructed on the site (temple D) commemorated Marcus Aemilius Lepidus' naval victory over King Antiochus in 179 BCE. It is partially covered by the contemporary street, Via Florida. The site was excavated and preserved under Mussolini's direction starting in 1938.

Significance Largo Argentina presently serves as an archaeological site and cat sanctuary illustrating one of the more unusual combinations of functions. Roads, pedestrian paths, and buildings around the site have been adapted to balance the demands of preservation and contemporary life. The sunken void of the site is largely inaccessible but is surrounded by pedestrian and vehicular activity. Although the temples on site span hundreds of years, they are presented as a singular experience—centuries frozen in one moment. Because access to the ruins is limited the only way to really grasp the scale of the ruins is to compare them to surrounding buildings. The
site is often activated on the Ides of March as part of re-enactments of the murder of Julius Caesar.

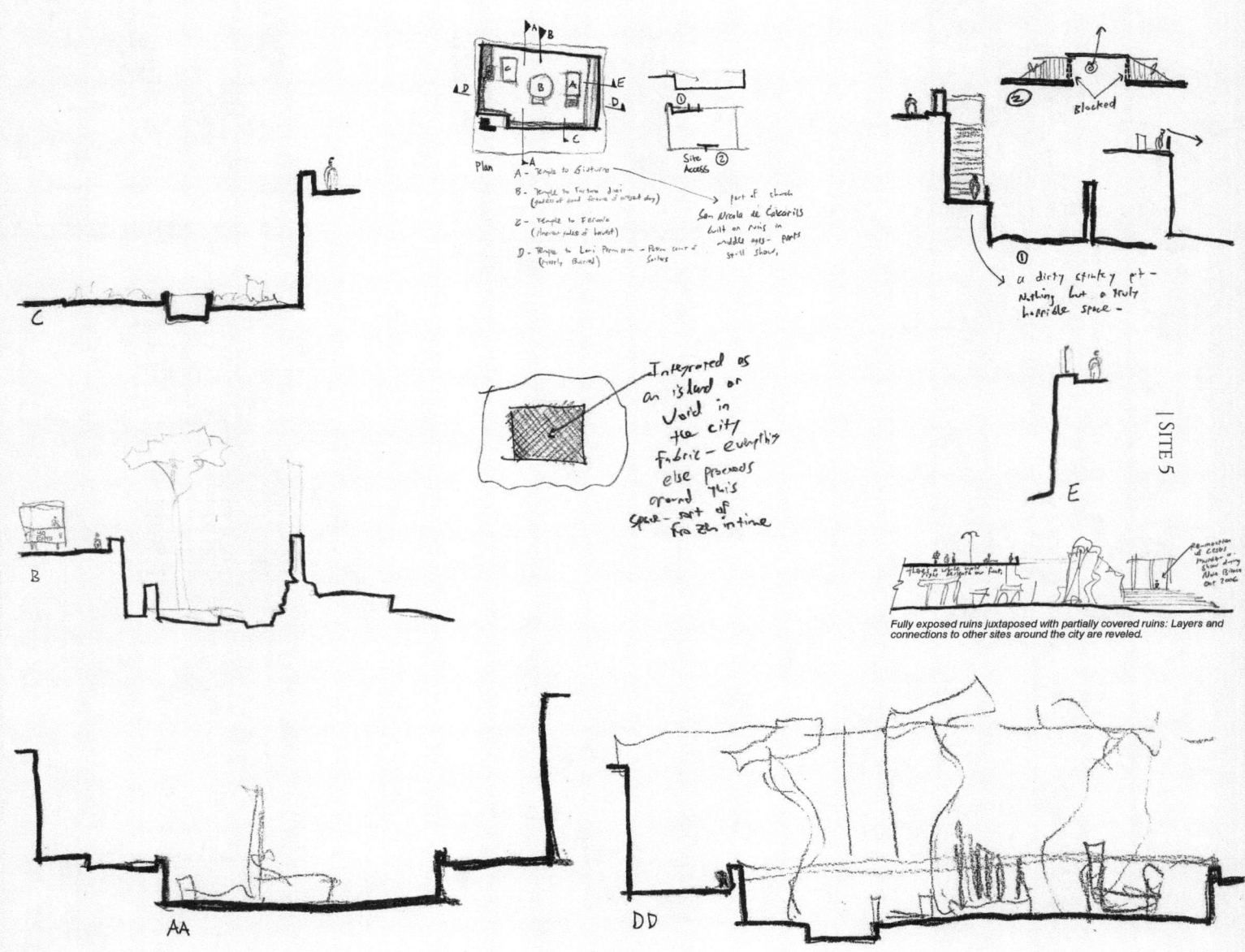

Fully exposed ruins juxtaposed with partially covered ruins: Layers and connections to other sites around the city are reveled.

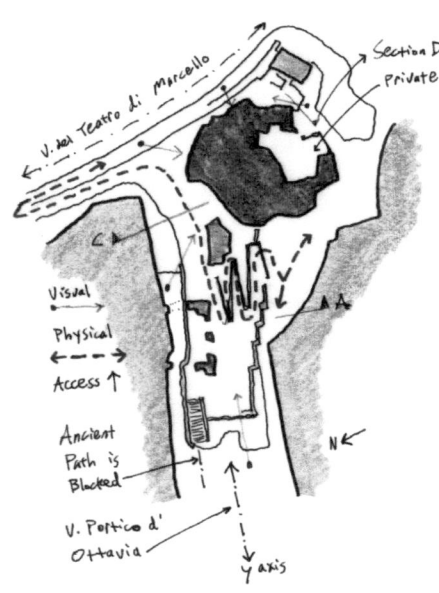

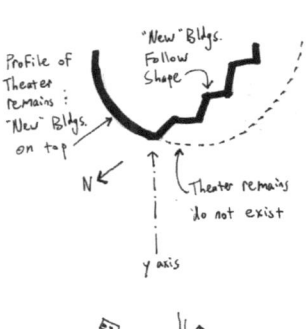

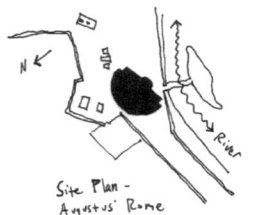

Site Plan - Augustus' Rome

Layers combine to form a new integrated facade with varying materials and textures.

Individual parts combine to create a unified whole: Each part retains its own identity, but could not be removed without destroying the entire composition.

The theater is closed off and inaccessible, but its true scale and grandeur is revealed. The path (only open during the day) proceeds through a pit of ruins. This is an isolated space.

Two faces of the Theater Complex are revealed simultaneously: The stepping residential forms to the right (where an understanding of the theater diminishes) and the original circular form to the left (where an understanding of the form increases).

13 BCE Theater of Marcellus

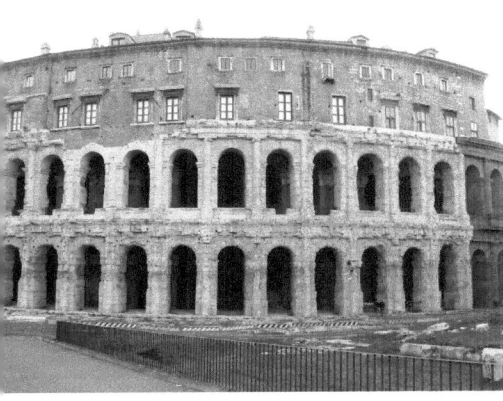

History The Theater of Marcellus, located near the base of the Capitoline Hill originally held approximately 15,000 spectators. Its design inspired the Coliseum. In the middle ages the site fell into disrepair and materials from it were pillaged for other uses. In the 16th century a palace and fortress was constructed on top of the theater; it was later remodeled as the Orsini Palace in the 18th century. In the 1930s buildings attached to the northeast side of the ruins were removed and the theater was rehabilitated. Parts of the Orsini Palace remain in existence and inhabited on top of the theater structure.

Significance Initial adaptations of the Theater of Marcellus were motivated by functional concerns and a desire to re-use the monumental existing structure. The 20th century adaptations placed greater emphasis on showcasing the theater as a relic and symbol of Ancient Rome. The end result illustrates the ways in which Ancient Roman structures serve multiple purposes; in this case the monument reflects symbolic, historical, and functional drivers. The monument is exposed to a wide busy road on one side, providing monumental views. The other side is knit into the urban fabric of the Jewish ghetto. This diverse contemporary context allows for different ways of viewing and experiencing the monument.

Original Theater Scheme Scheme in Current Form

| SITE 6

55 BCE Theater of Pompeii

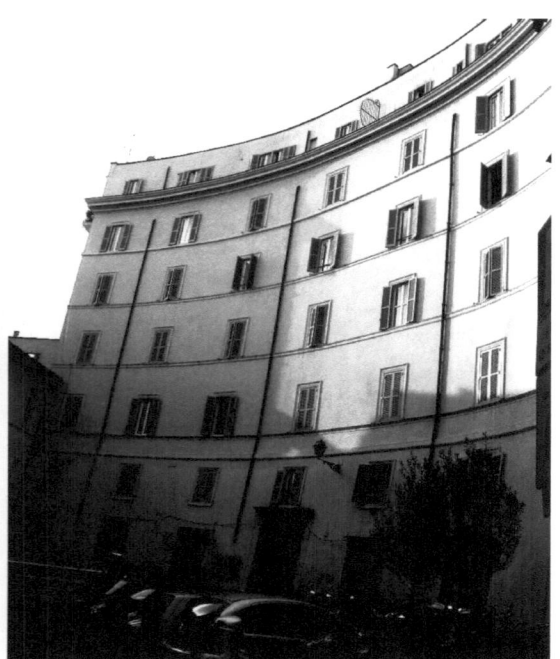

History The Theater of Pompeii, Rome's first permanent theater originally included a temple to Venus Victrix, the goddess of victory. With seating capacity for 18,000 people, the Theater of Pompeii became a model for later theaters. The theater fell into ruin and was then used as a material resource for later buildings nearby. Buildings on the site were added to and altered over centuries reflecting changing programmatic demands.

Significance While only traces of the Theater of Pompeii are visible today, the structure influenced the urban development of the neighborhood built upon and around it. Parts of the structure have been integrated into the buildings on the site. Facades offer clues about the intricate evolution of the site: some respond to the theater structure, some relate to the surrounding open space, and some abruptly end as a result of their relationship to the ancient structure hidden beneath.

The theater both directly and indirectly influenced the buildings and urban layout. Some buildings were constructed using the foundations of the theater while others were built in response to voids in the original urban design. Together these evolutions in urban design resulting from the influence of the Theater of Pompeii create a dynamic relationship between buildings, paths, and open spaces that is still palpable today.

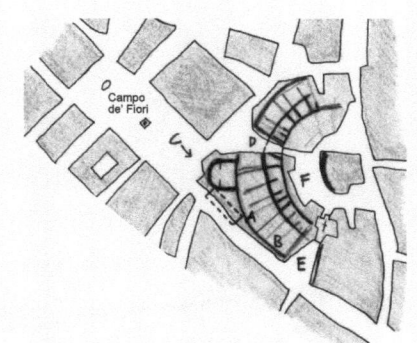
Site Plan

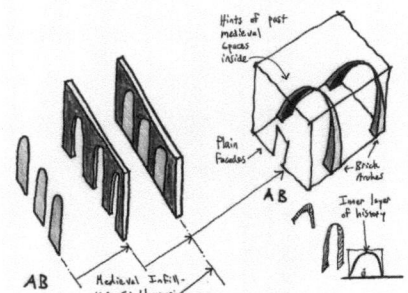

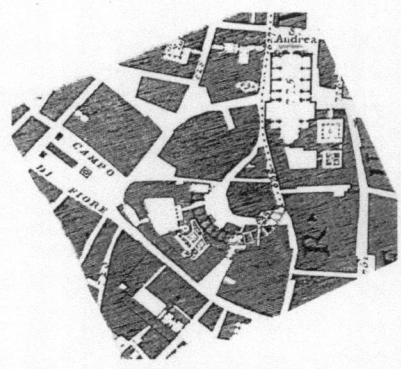
1748 Noli Plan (The theater orientation is inaccurate).

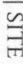
| SITE 7

Plan showing the physical forms of the theater that are still visible.

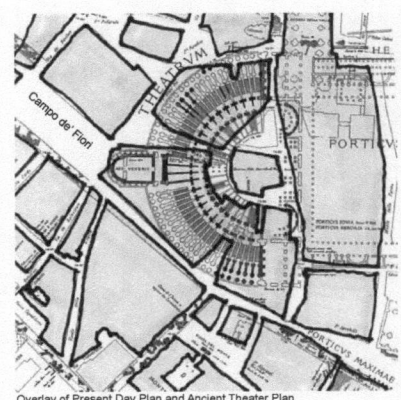
Overlay of Present Day Plan and Ancient Theater Plan

Layers of infill are displayed on the facades. Interior spaces offer additional clues to the theater structure and the medieval spaces constructed in response. As the forms remain constant, the interior spaces and decoration of the many high-end fashion shops in the area continue to change.

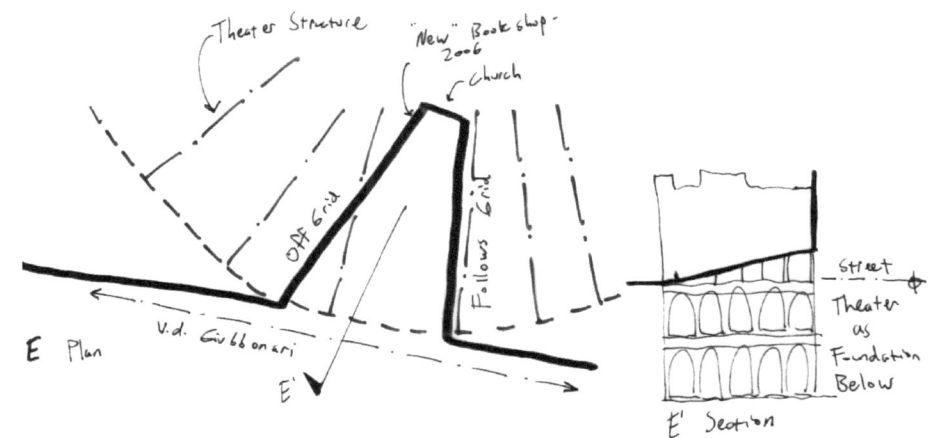

Campo de' Fiori, Palazzo Pio, Piazza Biscone and Via dei Giubbonari

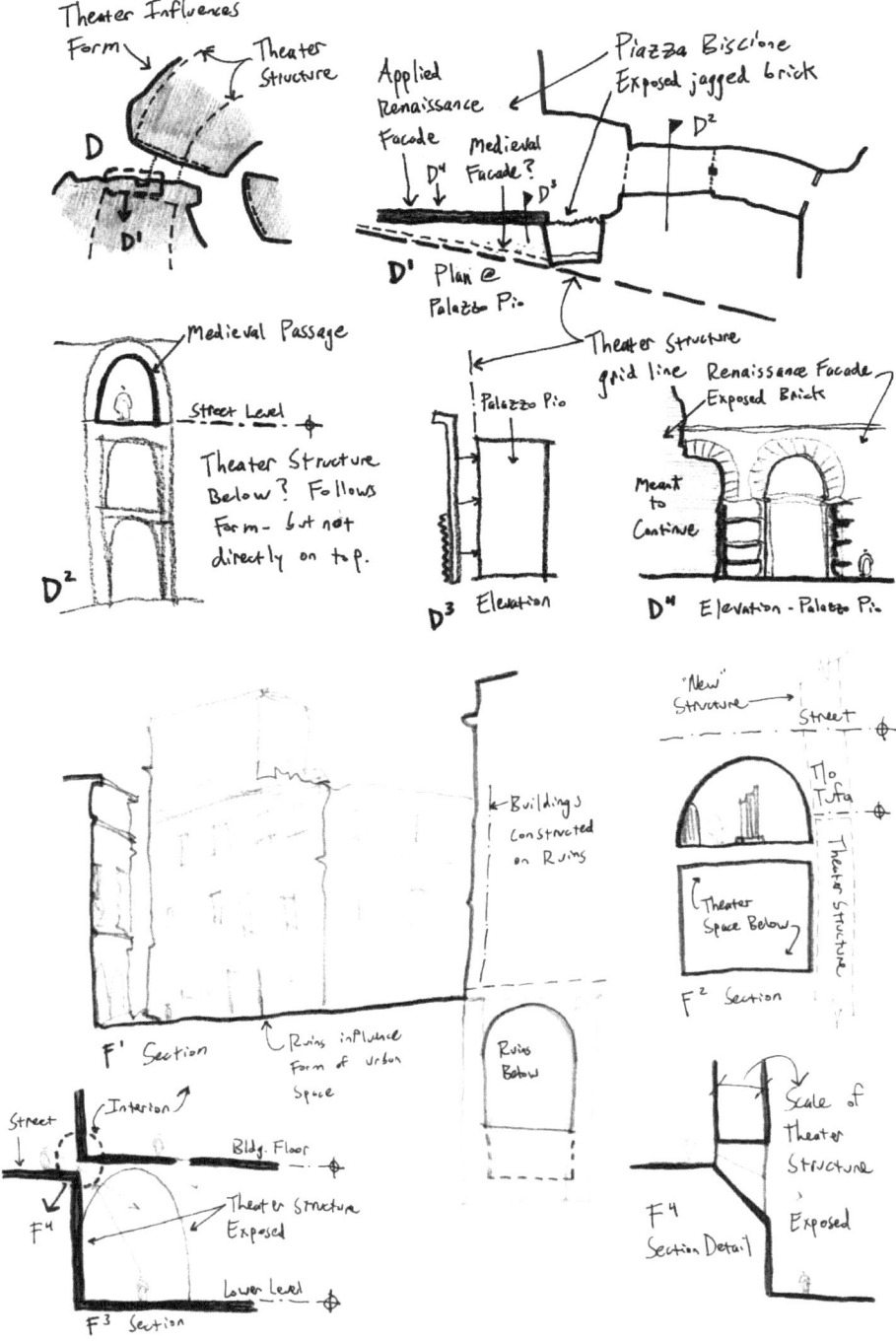

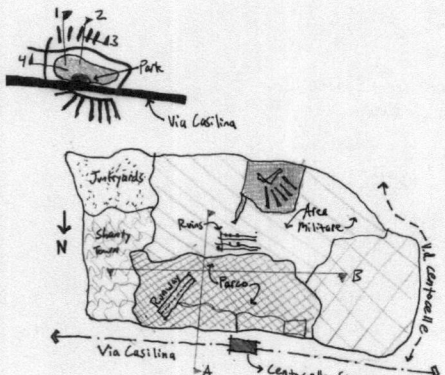

Site Plan and Key Plan

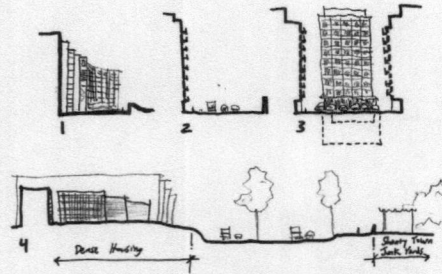

Context Sections: Open green space is more important in dense areas.

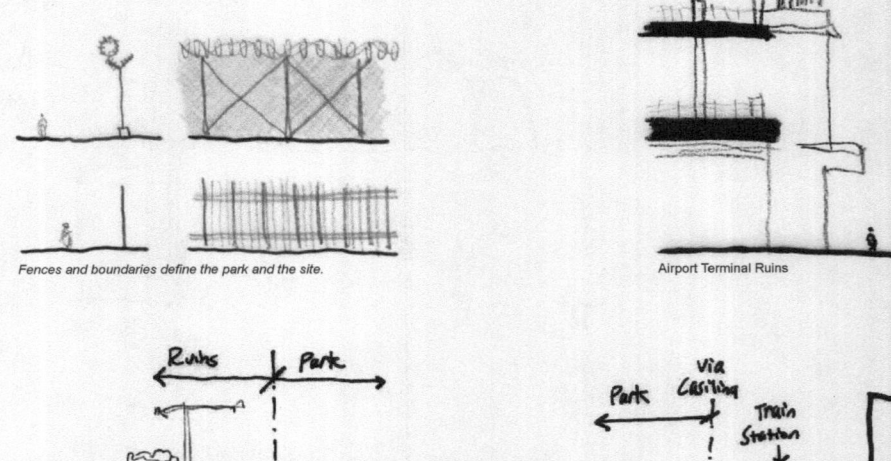

Fences and boundaries define the park and the site.

Airport Terminal Ruins

Site Section A

Site Section B

Elevation of Ruins

The unfinished concrete terminal structure (and remaining tower crane) stand not as a reminder of the past, but a monument to something that never was, but could have been.

Centocelle

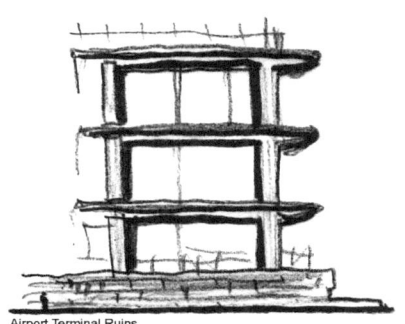
Airport Terminal Ruins

History The site includes a variety of ancient ruins, including two large 3rd century villas. Some ruins have been excavated but are inaccessible. A fort was constructed on the southern edge of the site in the late 19th century. In the early 1900s the site began to be used as an airfield. A military base was later constructed on site and included plans for Rome's fourth airport. These plans were later abandoned but the military base remained in use. The north portion of the site was converted into a public park in the late 1990s.

Significance Strangely the partially completed airport terminal was never used and thus evolved into a modern ruin. The site's primary function today is as a park. The military base, several junkyards, and a shantytown surround the park, which is only accessible from Via Casilina. Though not well connected, the park is still an important break in the neighborhood's dense urban fabric.

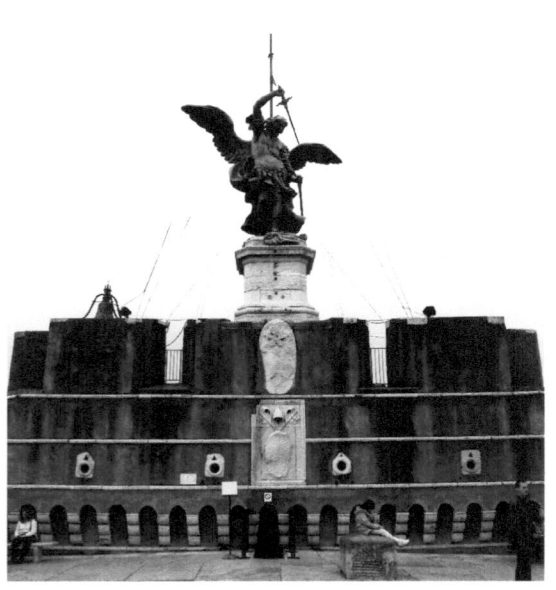

Castel San' Angelo

History The Emperor Hadrian commissioned his mausoleum, which forms the foundations of the present day Castel San'Angelo in 139 CE. Hadrian also commissioned the approaching bridge, Ponte San'Angelo as a ceremonial approach to his tomb. Succeeding emperor's ashes were placed inside the Mausoleum until 217 CE. The structure was later converted into a fortress and incorporated into the Aurelian wall in 270 CE. For centuries the structure was used as a prison and papal palace. In the early 20th century it was transformed into a museum.

Significance The Castel San'Angelo's current adaptation as a museum does an effective job of preserving the various layers of the site's history, especially the legacy of the mausoleum, fortress and papal residence. The museum includes gallery space for permanent and temporary exhibitions but the building's storied history is the primary focus. The building's many transformations are now frozen in time as a combination of history, path and place. The result is a dynamic environment with many different areas to discover and explore. The Ponte San'Angelo and the piazza in front of the building function as both path and place.

The site hosts an art and souvenir market where vendors position their goods to take advantage of the nearly constant pedestrian traffic. The building is a monumental backdrop for a lively and changing urban space. The park area surrounding the building creates a green break in the urban fabric. Vehicular traffic is diverted around the site along the riverfront. The Castel San'Angelo is experienced through a long procession traversing the site horizontally and vertically. Views out of the Castel San'Angelo at various points help orient visitors as they move through the building.

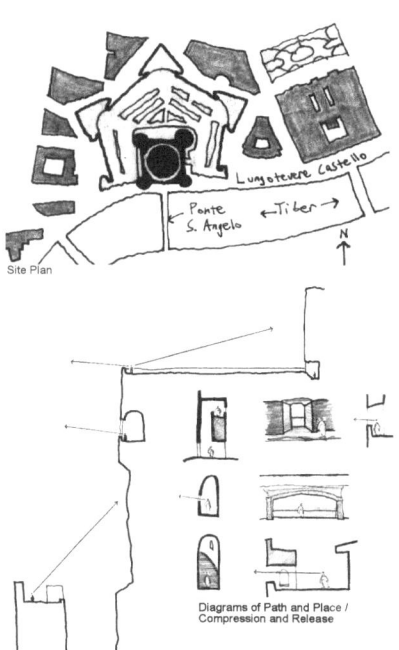

Site Plan

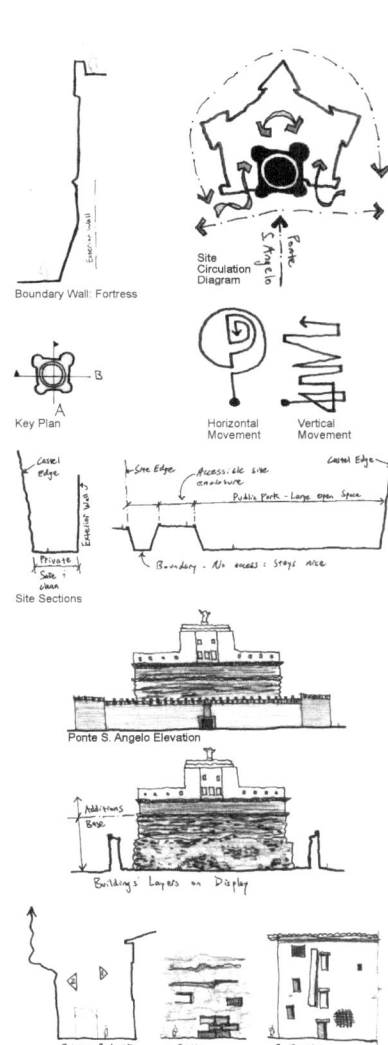

Boundary Wall: Fortress

Site Circulation Diagram

Key Plan
Horizontal Movement
Vertical Movement

Site Sections

Ponte S. Angelo Elevation

Building's Layers on Display

Mausoleum ruins remain as a structural foundation for subsequent additions. Medieval and Renaissance buildings fill the voids between the fortress walls and the Mausoleum and are viewed during the entry sequence.

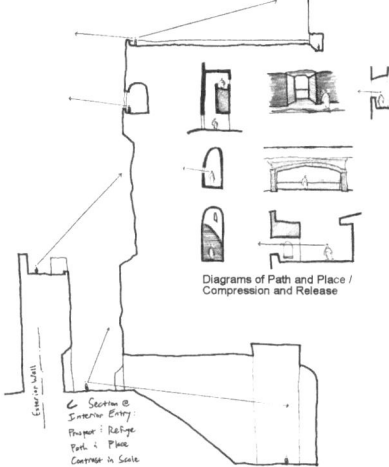

Diagrams of Path and Place / Compression and Release

Constantly changing views of Rome provide visual reference as one moves through the building. Views of the building's interior and exterior provide a secondary means of orientation.

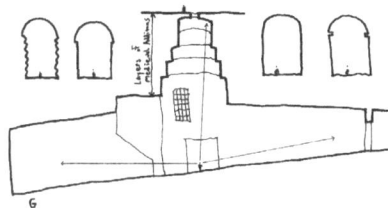

Varying materials and construction methods reveal additions and modifications. Light wells provide orientation and a sense of the building's massive scale.

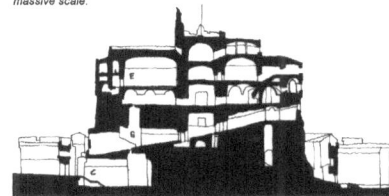

Section A

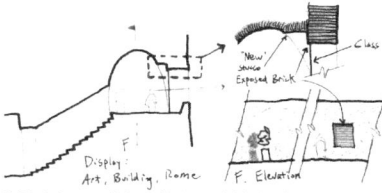

Building's layers on display and juxtaposed with artwork.

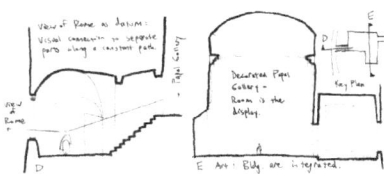

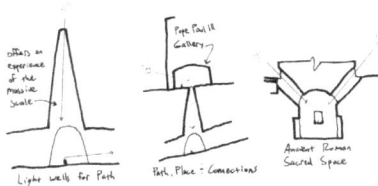

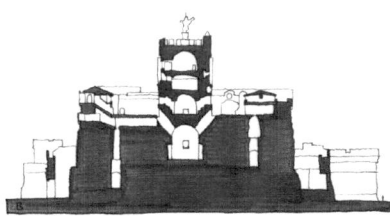

Section B

SITE 9

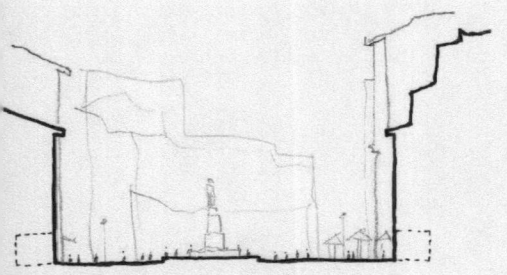
Section

→ — → Primary Access (Movement Through the City)
◆- - -◆ Vehicle Access
←- - -→ Secondary Movement
←- - -→ Primary Movement Beyond
☁ Place (Extension or within Piazza)
▭ Interior Place / Activity (Public Access)
● Indoor / Outdoor Activity (Public Access)
▦ Outdoor Activity (Market, Performers, Vendors)
◣ Extension of Activity (Beyond Piazza)

Diagram Legend

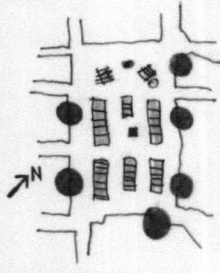
Early Morning: *Active Market and Bars*

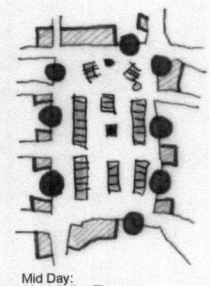
Mid Day: *Most Active Time*

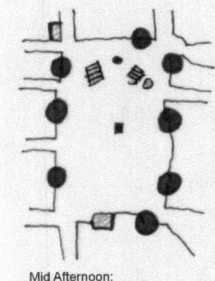
Mid Afternoon: *Shops Close*

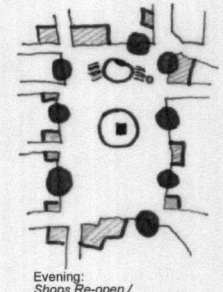
Evening: *Shops Re-open / Transformation to Night Life*

Campo de' Fiori Activity Diagrams

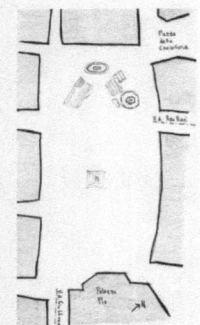
Campo de' Fiori Plan

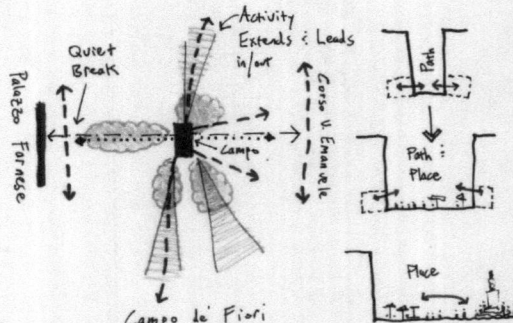
Combination of functions (shops, market and entertainment): The piazza itself is the primary architectural element, while Bruno's monument and the fountain are secondary features.

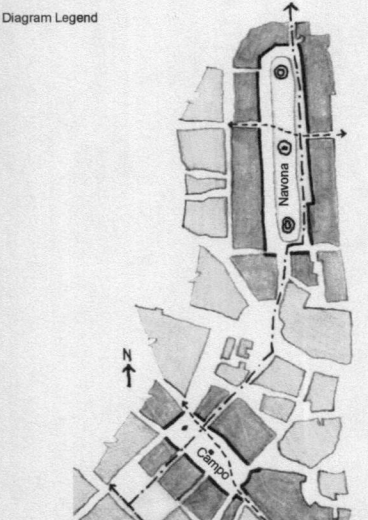
Site Plan

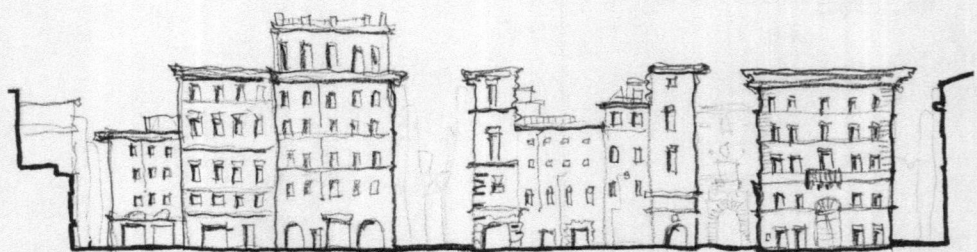
Campo de' Fiori Section

Campo dei Fiori

History The Campo dei Fiori is named after the field of flowers that existed on the site before the present piazza. The site of the Theater of Pompeii forms the south edge of the Campo dei Fiori. The piazza was enlarged to its current size in 1858. The philosopher Giordano Bruno was burnt alive as part of the Roman Inquisition in 1600. A monument to Bruno was placed in the center of the piazza by the city government in the late 19th century. Today the site is home to restaurants, shops, and bars as well as an active market, which was transferred from Piazza Navona in 1869.

Significance The piazza reflects the fluid adaptation and continued use of urban space. They have become icons of the city for both residents and visitors and have a magical and timeless yet always lively character.

Piazza Navona

History Piazza Navona was constructed on top of and derives its shape from the Ancient Circus Agonalis stadium commissioned by Domitian. The stadium held 30,000 spectators and was used for competitions as well as mock sea battles. Medieval and Renaissance buildings were built upon the structure of the stadium. The piazza in the center took its present shape in the 14th century. The Fountain of the Four Rivers in the center of the piazza was designed by Bernini in 1648. San'Agnese in Agone was redesigned by Borromini and others from 1653 to 1670. On the north end of the site two buildings were removed and reconstructed in the 1930s as part of Fascist work in the historic center. The new buildings include arcades at ground level, which allow visitors to peer into the structure of the ancient stadium below.

Significance Piazza Navona, like Campo dei Fiori, is an urban space that has been in use and continuously adapted over centuries. Both sites have limited vehicular access allowing pedestrians to dominate. Today Piazza Navona serves as a stage for performers, artists and tourists alike set against the backdrop of the fountains and façade of San'Agnese. The activity of the piazza spills over into the surrounding streets. In the winter it is home to a holiday market. The vast linear space is punctuated and divided by Bernini's fountain in the center and smaller fountains at either end. The ruins, however, are experienced separately as one must exit the piazza in order to view them.

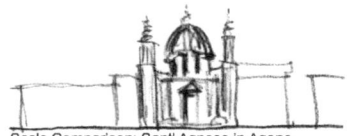
Scale Comparison: Sant' Agnese in Agone

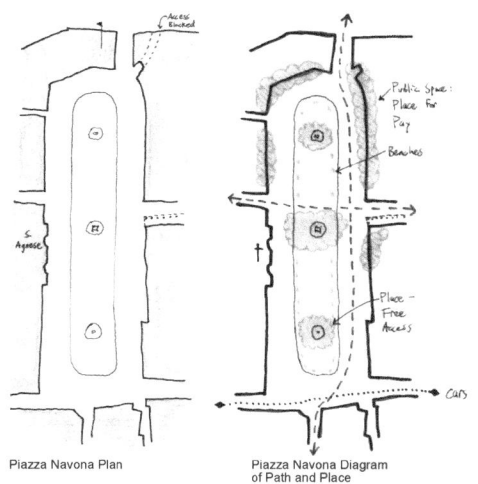

Piazza Navona Plan

Piazza Navona Diagram of Path and Place

Early Morning: *Limited Activity*
Piazza Navona Activity diagrams

Mid Day: *Restaurant Activity Dominates*

Mid Afternoon: *Activity Increases*

Evening: *Becomes Magical and Enchanted*

	Primary Access (Movement Through the City)
	Vehicle Access
	Secondary Movement
	Primary Movement
	Place (Extension Beyond or within Piazza)
	Interior Place / Activity (Public Access)
	Indoor / Outdoor Activity (Public Access)
	Outdoor Activity (Market, Performers, Vendors)
	Extension of Activity (Beyond Piazza)

Diagram Legend

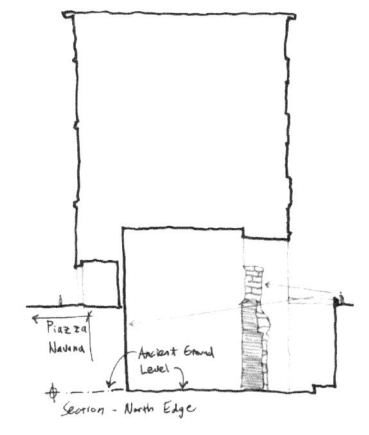

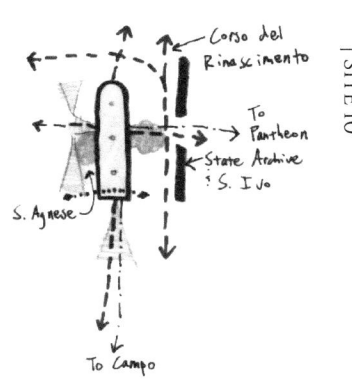

SITE 10

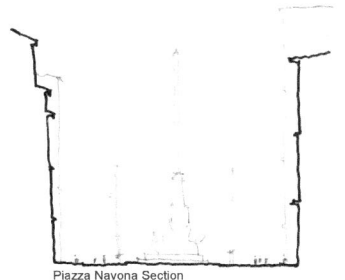

Piazza Navona Section

Piazza Navona Sections

The Pantheon & Piazza della Rotonda

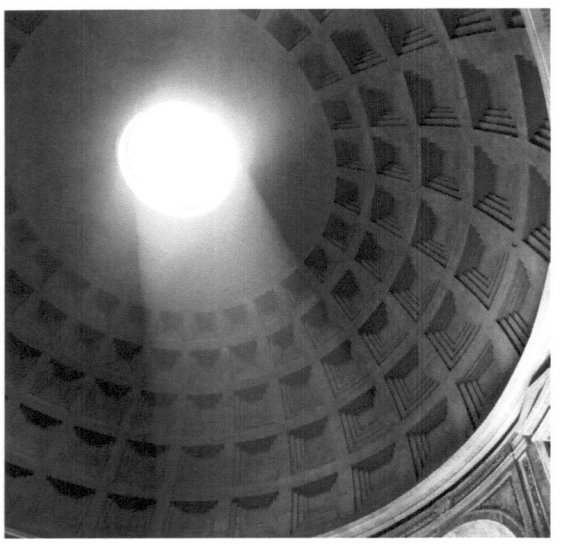

History The site of the Pantheon was home to an earlier Roman temple constructed by Agrippa from 27-25 BCE. The Pantheon we see today was constructed under the Emperor Hadrian from 118-125 CE. In 609 CE, the building was converted to the church, Santa Maria dei Martiri by Pope Boniface IV. Over the centuries, however, many of the finish materials were removed and re-used elsewhere. The piazza in front of the Pantheon was commissioned by Pope Clement XI in the 18th century.

Significance The transformation of the Pantheon into a church in the middle ages helped to ensure its preservation unlike many other Roman temples. The integration of the piazza with the Pantheon is achieved in part through contrast with the surrounding urban fabric. The Pantheon's position within a maze of narrow streets allows it to be discovered and the dramatic contrast in the scale of the piazza and temple creates one of the city's most awe-inspiring places. Piazza Rotonda shares many characteristics with Campo dei Fiori and Piazza Navona. It is a multi-functional space often teeming with tourists and Romans alike. Limited vehicular access enables it to remain a lively and memorable space.

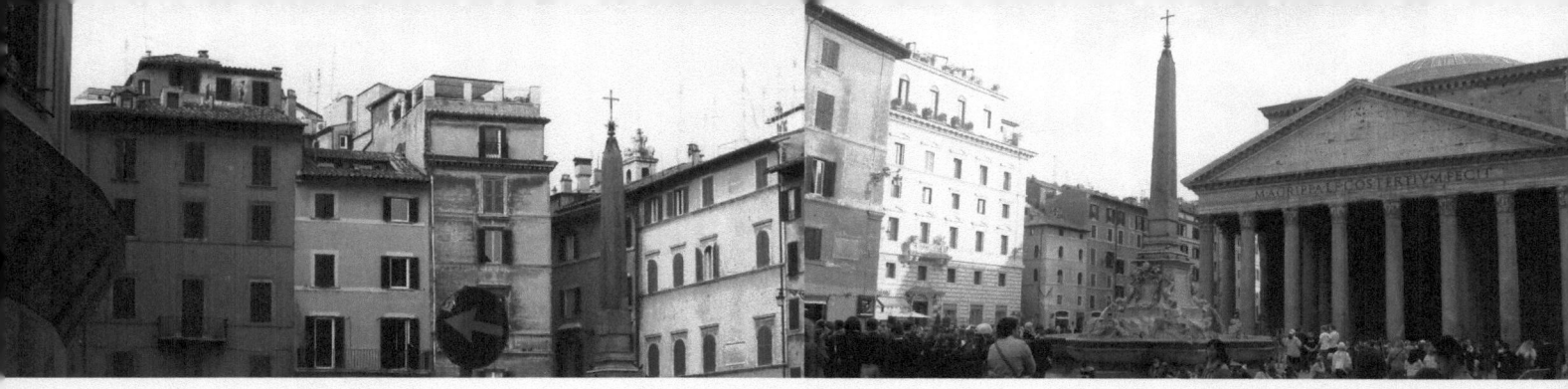

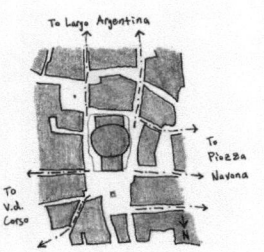
Site Plan

Piazza Elevation

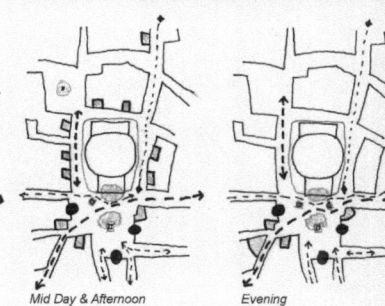
Early Morning / Mid Day & Afternoon / Evening
Activity Diagrams:

Diagram Legend
- ←·–·→ Primary Access (Movement Through the City)
- ←····→ Vehicle Access
- ←----→ Secondary Movement
- ←——→ Primary Movement
- Place (Extension Beyond or within Piazza)
- Interior Place / Activity (Public Access)
- Indoor / Outdoor Activity (Public Access)
- Outdoor Activity (Market, Performers, Vendors)
- Extension of Activity (Beyond Piazza)

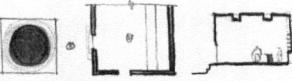
Scale Comparison Diagrams:
Pantheon Column vs. Typical Bar

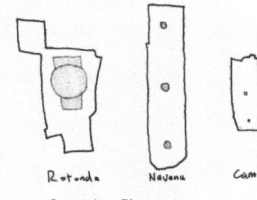
Rotunda Navona Campo
Comparison Diagrams

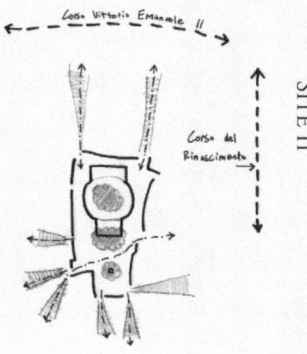
SITE II

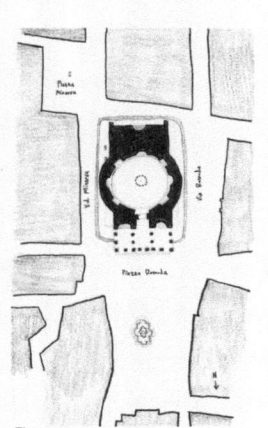
Plan

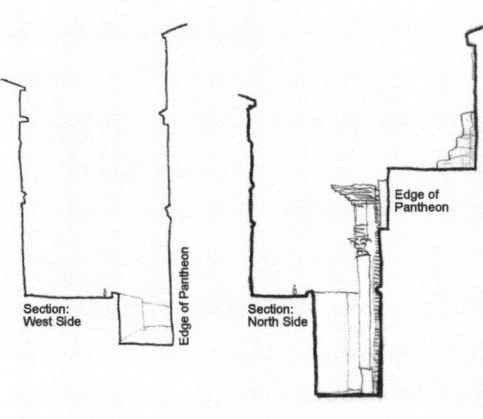
Section: West Side — Edge of Pantheon
Section: North Side — Edge of Pantheon

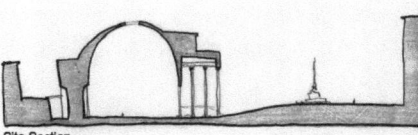
Site Section

12. Museum of the Ara Pacis
13. Auditorium Parco della Musica
14. Centrale Montemartini
15. Peroni Complex
16. MACRO al Mattatoio
17. Baths of Caracalla
18. Palazzo Massimo alle Terme
19. Palazzo Altemps

PART II
Building Scale Projects

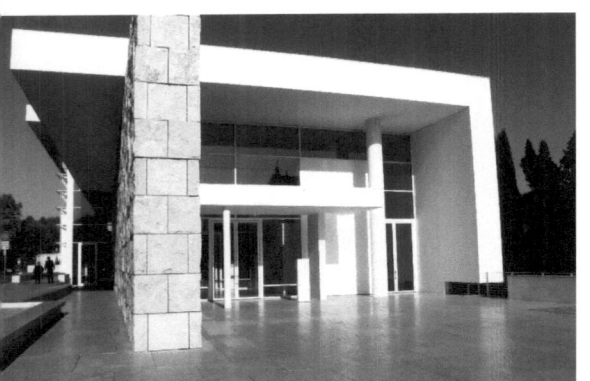

History The Ara Pacis is an ancient altar commemorating peace won through military victories in Gaul and Spain under Augustus. As the Roman empire declined the altar was broken and scattered. In the 1930s, Mussolini supported an effort to recover lost pieces and reassemble the altar. It was reassembled not on its original site but rather near the Mausoleum of Augustus. At the same time the surrounding area of the mausoleum was redesigned and the mausoleum was excavated. A new museum showcasing the Ara Pacis was constructed between the Tiber and the Mausoleum in the late 1930s. This structure was demolished and another museum, designed by the American architect Richard Meier, was constructed on the site in 2006. Meier's building was the first wholly new construction in the historic center in decades and has been the subject of much controversy.

9 BCE Museum of the Ara Pacis

Significance The reconstruction of the Ara Pacis and museums to display and preserve it were motivated in part by Mussolini's desire to link his imperial ambitions to those of Rome's first emperor, Augustus. Moreover, the altar allowed him to capitalize on the idea that war may lead to peace as expressed in the altar. The new building is centered around the altar but also includes an auditorium, bookstore, and exhibition spaces. High-tech materials and mechanical systems help improve conditions for preservation. In the end, however, the complexity, lighting, and whiteness of the building take attention away from the altar.

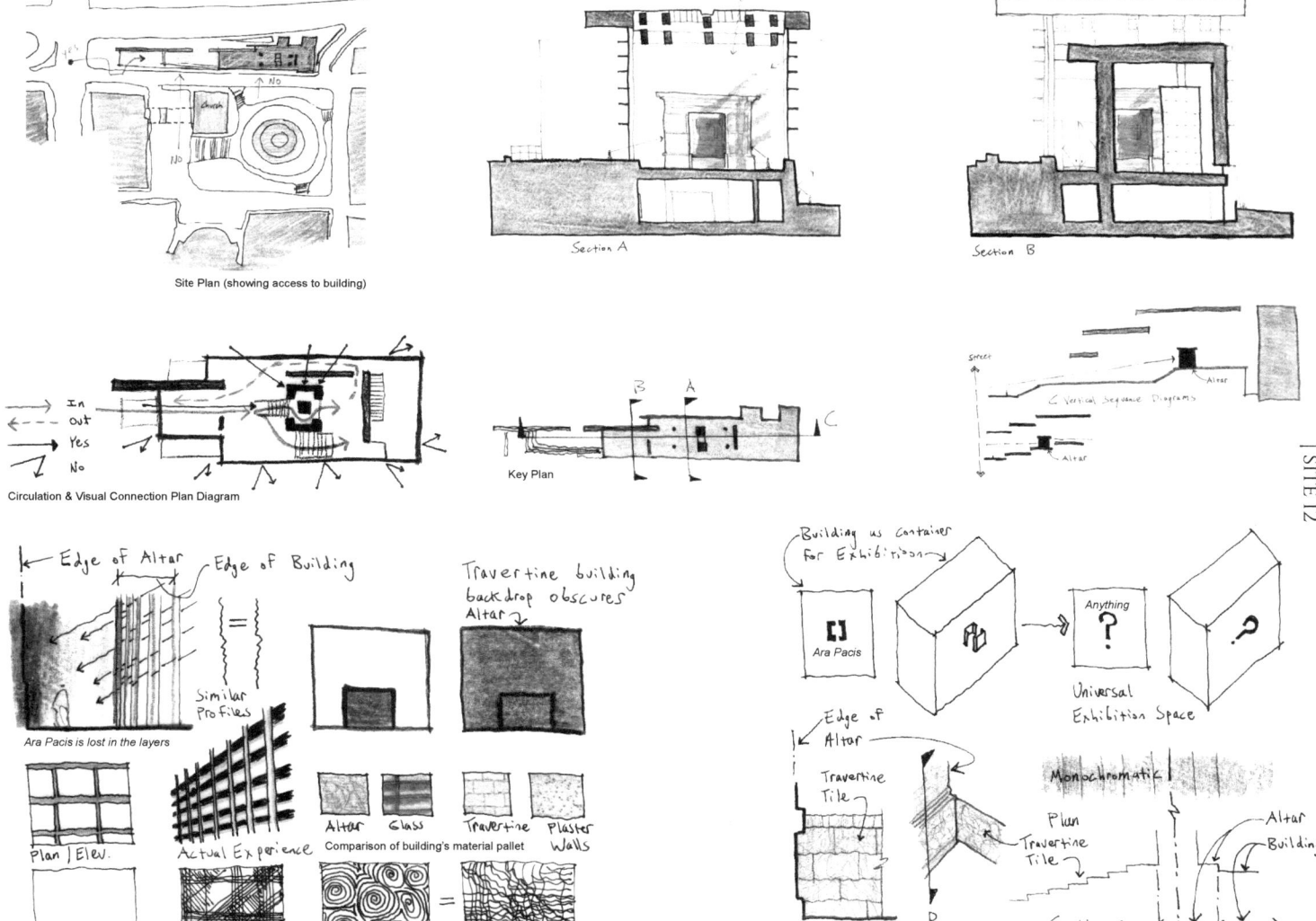

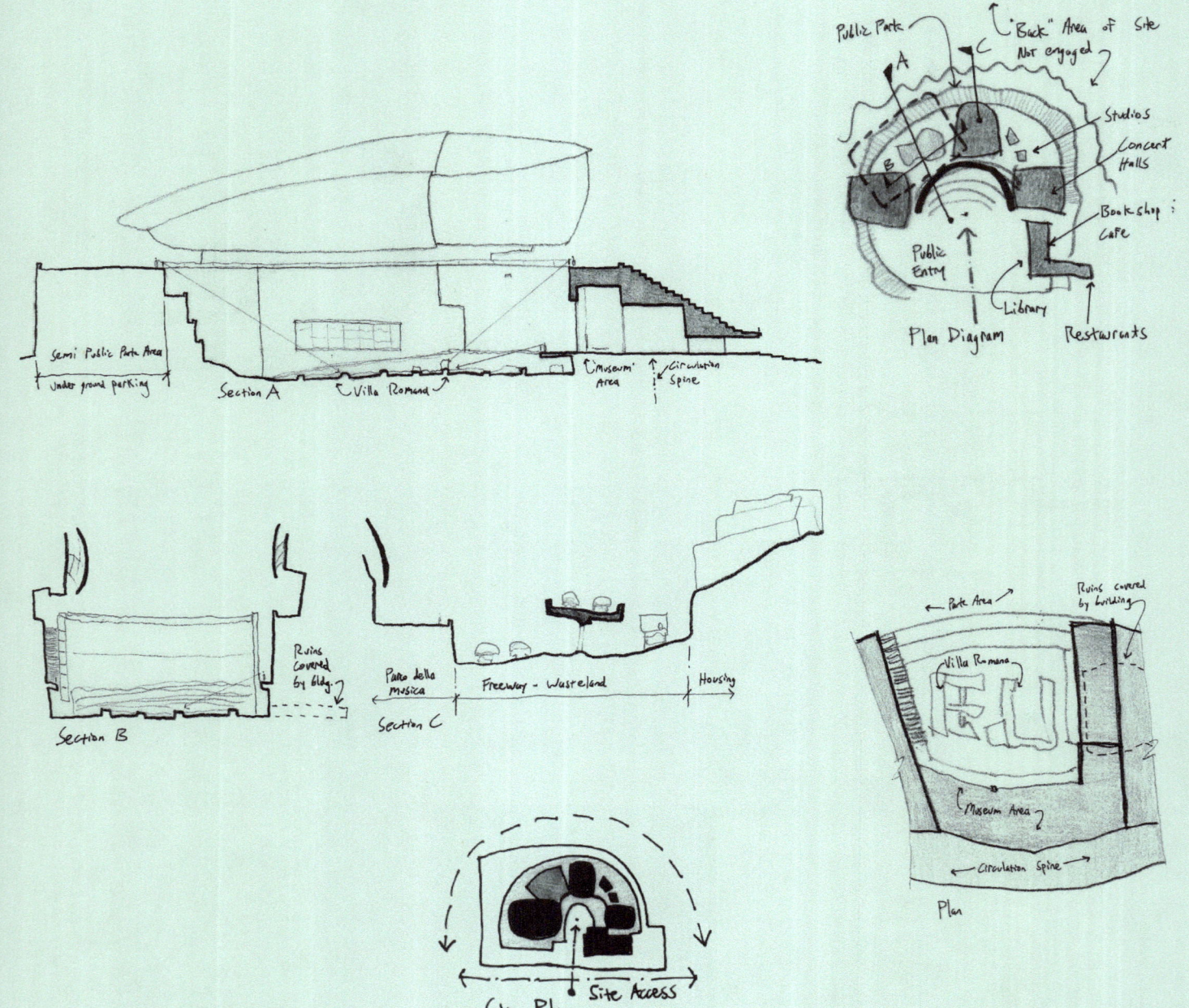

2004 CE Auditorium Parco della Musica

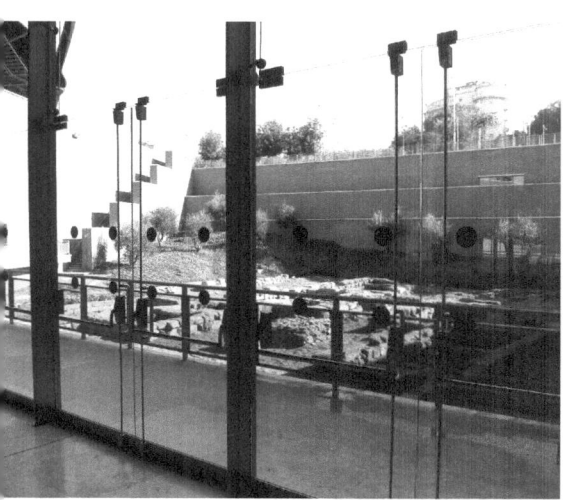

History The Parco della Musica, Rome's auditorium, was designed by architect Renzo Piano. During the construction of the project, the remains of an ancient Roman farmhouse (550-600 BCE) were discovered on the site, necessitating that the architect modify the design to accommodate and showcase the ruins. It is believed that the farmhouse and later villas on the site were likely abandoned around 150 CE.

Significance The Parco della Musica presents one of the most clear examples of the collision of two distinct layers of Roman history. The ruins of the ancient domestic buildings are showcased in a courtyard situated between the organic and modern volumes of the auditoria. Visitors can survey the ruins from the public spaces of the complex. The Parco della Musica also includes recording studios, restaurants, a bookstore, and a semi-public outdoor performance space. The project demonstrates how contemporary functions can be integrated with preservation in a successful and engaging manner.

Centrale Montemartini

History The Centrale Montemartini, Rome's first electricity plant, opened in 1890 and was in operation until the 1930s. The complex is adjacent to Italgas, whose wire frame gas towers, no longer in use, act as industrial icons and visually locate the Garbatella and Ostiense neighborhoods from around the city. In 1997 the Capitoline museums began using the site as a temporary museum during reconstruction. The exhibition has since become permanent.

Significance The industrial complex has been adapted to serve new programmatic and functional needs as a museum showcasing portions of the Capitoline collections. Thus it allows for a clear contrast between ruins of two different eras: ancient Rome and the industrial ruins of the early 20th century. Pristine white sculptures stand in stark contrast to the heavy black machinery of the plant. The building, machinery, and art works are integrated into a unified and dynamic display.

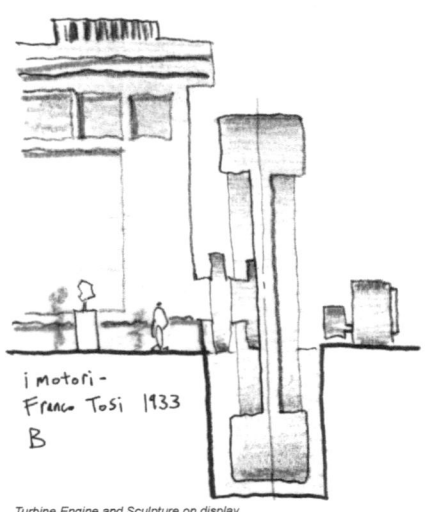

Turbine Engine and Sculpture on display.

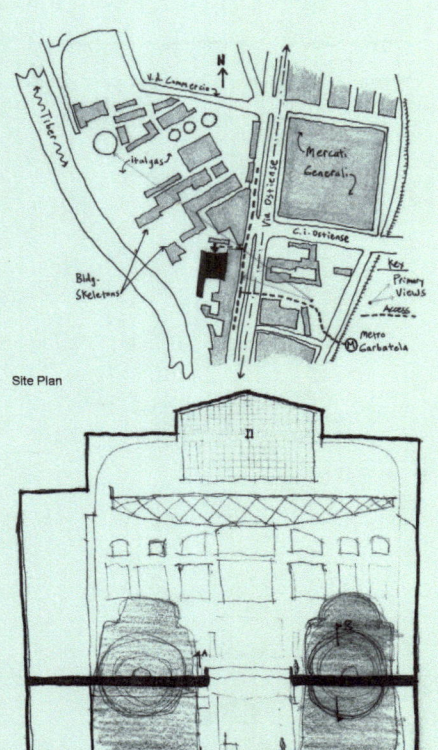

Site Plan

The Piston

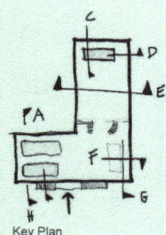

Key Plan

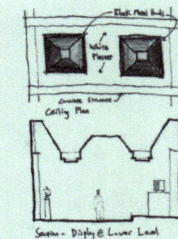

Utilitarian industrial form transformed into an aesthetic ceiling treatment.

A

The lower level display space focuses on the turbine engines and the building's industrial history. The machinery then becomes a contrasting backdrop for sculptural displays on the upper level: "The Gallery of the Machine."

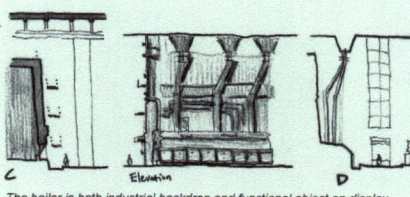

The boiler is both industrial backdrop and functional object on display.

Plaster display elements and lighting frames are a separate system (not part of the sculpture and not part of the building).

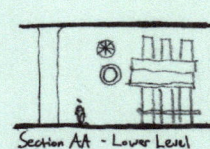

Translucent glass create ghosted images of the industrial site and becomes another backdrop for the art.

Section AA – Lower Level
Machine is the focus.

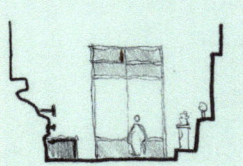

Machine – Dark, Rust, Grit
Stark White Sculpture

SITE 14

Finely crafted utilitarian machinery vs. Finely crafted pristine sculpture. Functional objects transformed into art.

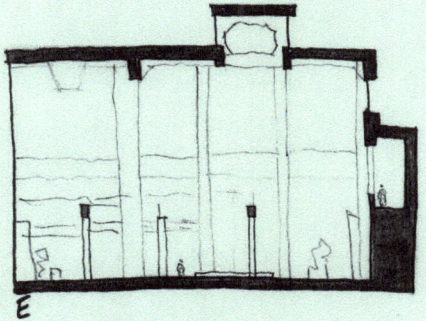

E

Industrial concrete structure creates a universal exhibition space.

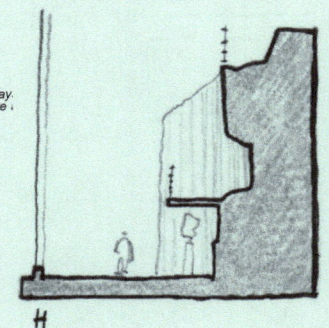

Contrasting display building, sculpture machine.

H

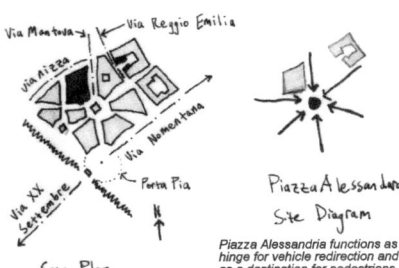

Piazza Alessandria functions as a hinge for vehicle redirection and as a destination for pedestrians.

Site Plan / Piazza Alessandria Site Diagram

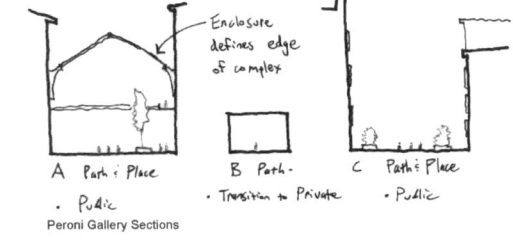

Peroni Gallery Sections
- A Path & Place · Public
- B Path · Transition to Private
- C Path & Place · Public

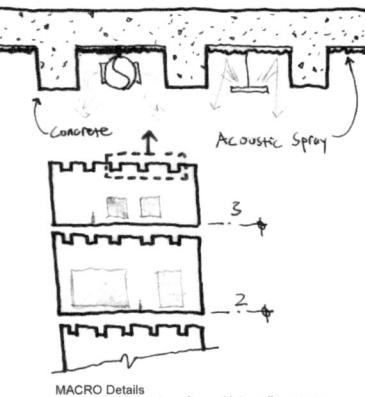

MACRO Details
Industrial building transformed into gallery space. Building is background: Art becomes the focus.

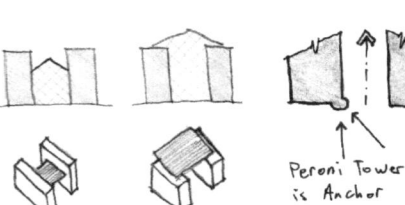

Systems of enclosure: Individual buildings combine to create an integrated and usable in-between space.

Peroni Tower is Anchor

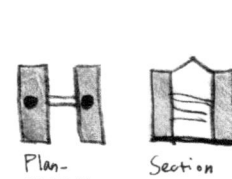

MACRO Diagrams — Plan / Section

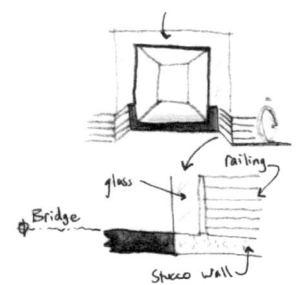

MACRO Details
Design separates contemporary functions from the industrial building through reveals in plan, elevation and section.

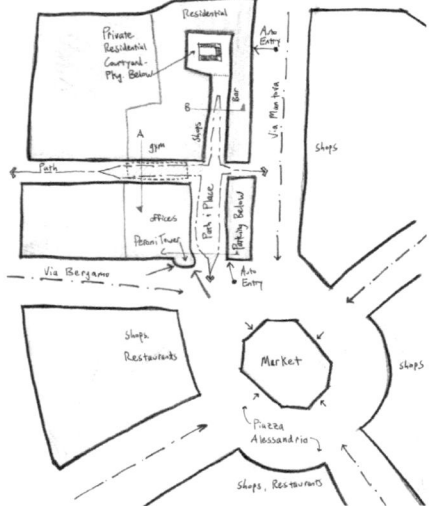

The Peroni gallery incorporates path and place.

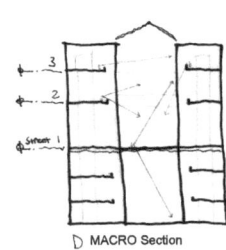

D MACRO Section

 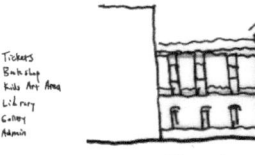

MACRO Floor Plans — Street Level 1 / Level 2 / Level 3

1. Tickets
2. Bookshop
3. Kids Art Area
4. Library
5. Gallery
6. Admin

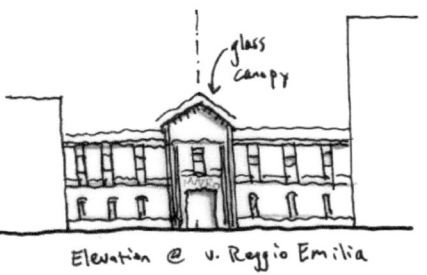

Elevation @ v. Reggio Emilia

MACRO

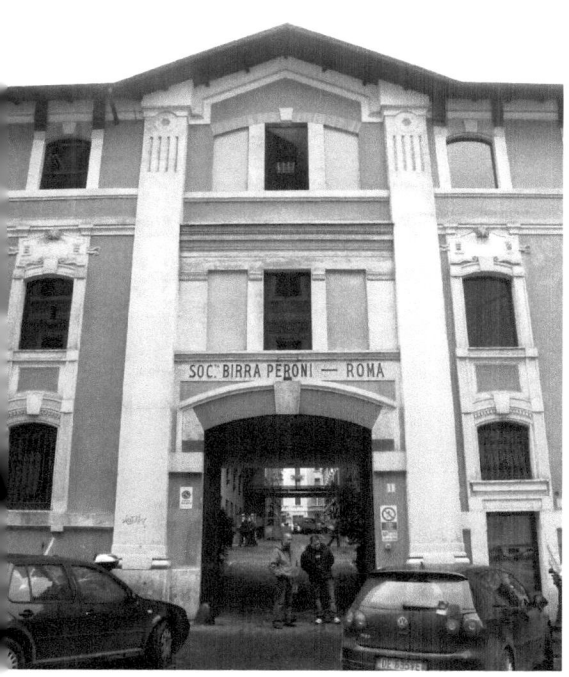

Peroni Complex

History The Peroni factory on Via Mantova was designed by Gustavo Giovanonni and constructed in 1908. The complex was expanded from 1912-22 and then abandoned in 1970. The complex was renovated and the façade restored in 1987. The current complex includes: underground parking, banks, offices, a spa, a wine bar, a restaurant, a gym, housing and a department store. The industrial building on Via Reggio Emilia was transformed into the Museum of Contemporary Art Roma (MACRO) in 1999. MACRO was expanded to include a new wing in 2010 designed by Odile Decq. The new wing includes street front galleries, a roof garden and a new entry.

Significance The adaptation of the Peroni complex serves to preserve the site as well as meet new programmatic and functional demands. The industrial buildings offer flexibility, which has proved to make them easy to adapt to new uses. The MACRO museum and expansion adds another layer of re-use and cultural significance. The complex's success is aided by the lively and well-connected neighborhood. Underground and internal parking areas serve visitors and residents. The overall character of the Peroni complex is preserved.

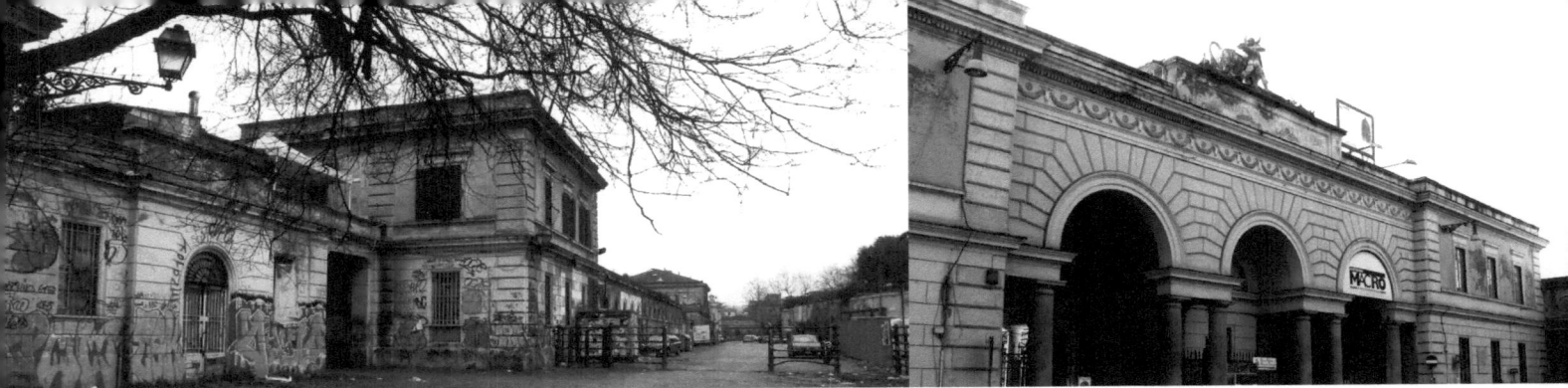

MACRO al Mattatoio

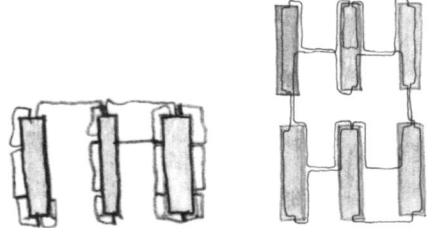

Plan Diagram: *The exterior and interior metal tracks, once used to transfer animal carcasses from building to building, now function as decoration and help unify the complex.*

History The originally mattatoio or slaughterhouse in Testaccio was constructed from 1888 to 1891. It exemplified advanced industrial architecture at the time. The industrial site, adjacent to Monte Testaccio was selected by city administrators as the site of the new slaughterhouse because of its proximity to the river. The surrounding neighborhood was planned to house artisans and the working class. It has since developed into one of Rome's thriving areas for youth culture and contains a lively mix of bars, night clubs, and restaurants. The slaughterhouse was closed in 1975 and the neglected site later fell into decay. Redevelopment of the site was started in 2000 as part of an initiative to provide gallery spaces in the area and accommodate Rome's third university. Renovation of the second art building was completed in 2007. Buildings have been adapted to provide space for art and music education. Other buildings are in the process of being renovated.

Significance The goals of preservation and reuse work together at this site to reflect a combination of historical significance and contemporary interest. The site's industrial history, structure, and layout has been maintained and partially re-used. The character of the buildings has been well preserved through restoration, though some buildings remain in states of decay. Elements of the architecture of the slaughterhouses have been incorporated into the new designs. The industrial aesthetic of the complexes forms a sort of ornament and backdrop for the new uses. The slaughterhouse experience is still palpable and adds an eerie sense to the site. The complex provides flexible space and a variety of indoor and outdoor activities that complement the neighborhood's character.

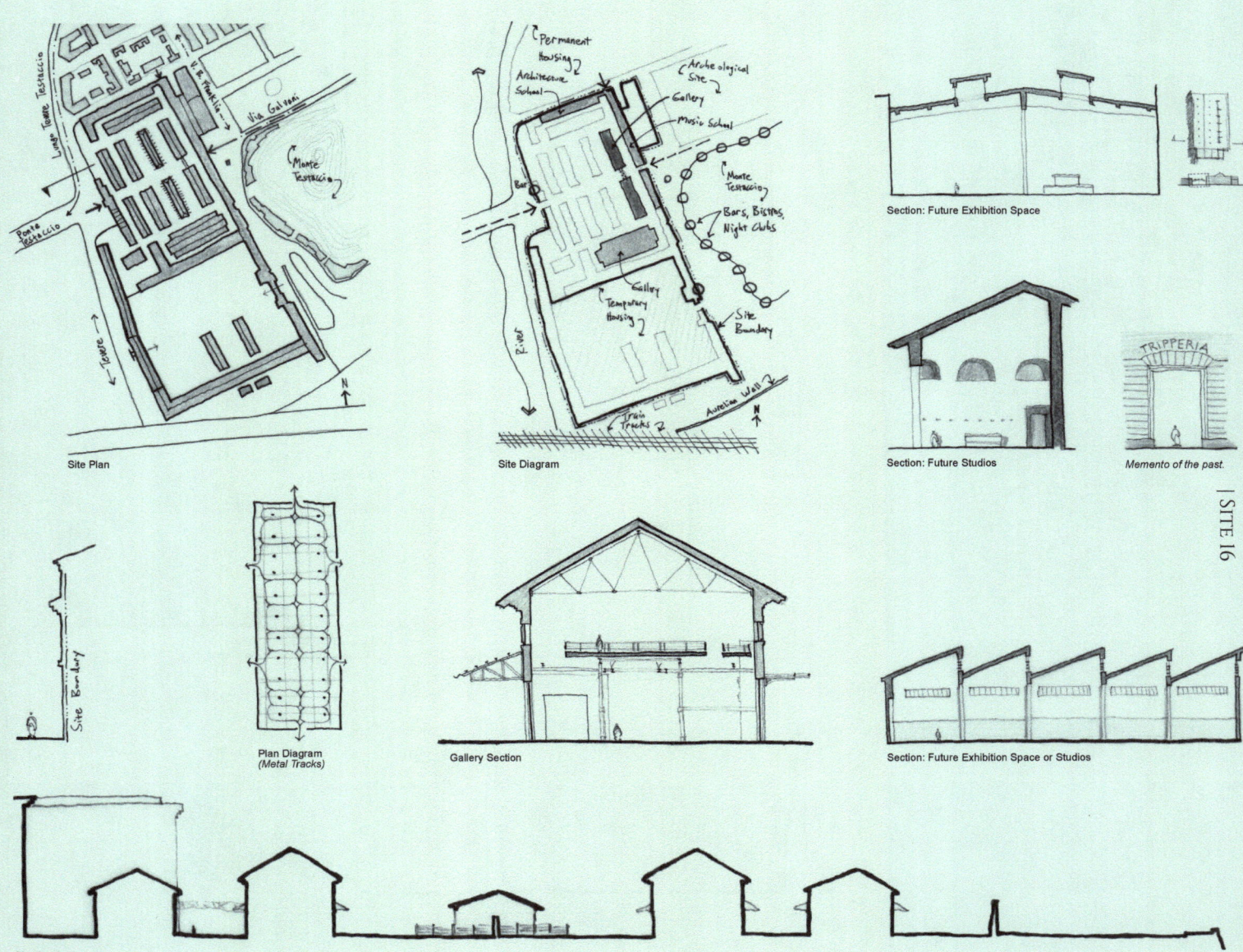

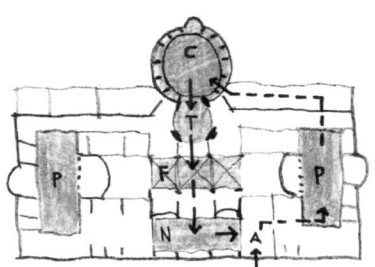

A - Apodyteria (Dressing Rooms)
P - Palestra
C - Caldarium
T - Tepidarium
F - Frigidarium
N - Natatio (Pool)

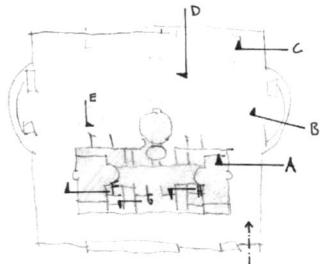

Key Plan

Plan

Section B

Elevation G

Plan Detail

Section C

Section H

Section E (Toilet Rooms)
Contemporary Services Concealed

Section F

Voids
Brick Wall
Stone Decoration Remains

Wall Layers

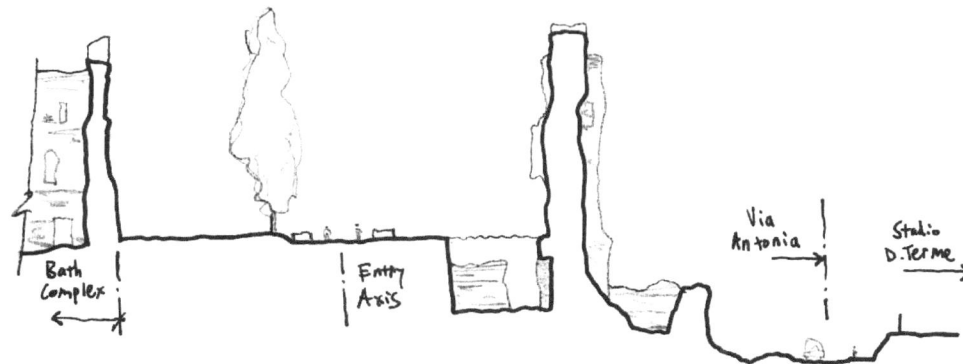

Section A: The *Baths'* massive scale and materials are the primary focus.

The Baths of Caracalla

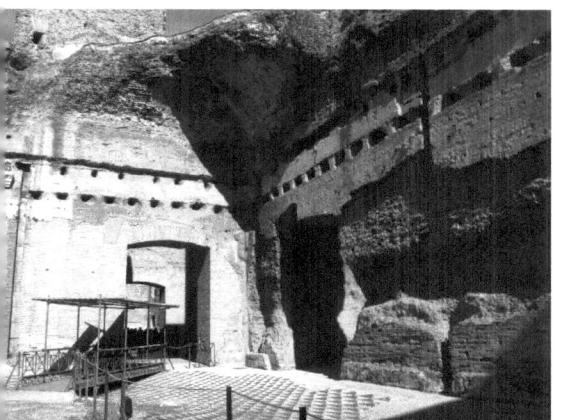

History The Baths complex commissioned by Emperor Caracalla was inaugurated in 216 CE and ultimately completed in 235 CE and held 1,600 visitors. They were later restored by Emperor Diocletian and Aurelian. The Caldarium was modified by Emperor Constantine. In 537 CE, the complex was abandoned after the water supply was damaged during a siege of the city. The baths lost their function and importance during the middle ages when the city shrunk to a small population in the Campus Martius. Under Pope Paul III, the site was partially excavated in order to harvest materials for the construction of Palazzo Farnese in the 16th century. Excavations continued into the 18th and 19th centuries. The site has since been transformed into a museum and archaeological site.

Significance The Baths of Caracalla serves as a backdrop for a summer opera series. Portions of the site are accessible to visitors as an enclosed park. The monumental ruins stand amidst a quiet and peaceful site. Utilitarian brickwork and decorative floor and wall materials are visible throughout the site. Layers of construction materials and methods of construction are revealed throughout the complex. Structural preservation work is ongoing throughout the site. Contemporary facilities are minimal and subtly incorporated throughout the site to minimize disruption.

Palazzo Massimo alle Terme

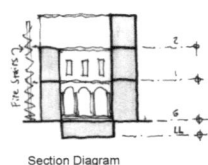

Section Diagram

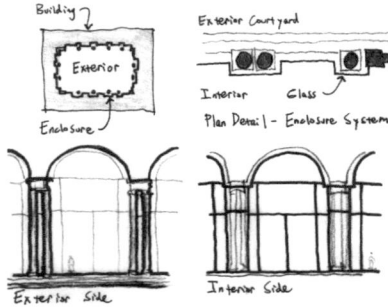

The ground floor enclosure system fades away when viewed from the interior.

History The Palazzo Massimo alle Terme was designed as a Jesuit College by Camillo Pistrucci in 1887. It was transformed into a museum in 1998 in order to display ancient Greek and Roman artifacts.

Significance The structure has been adapted to serve new programmatic uses as a museum but the character and scale have been preserved as they were well suited to the new use. The art is experienced in a setting removed from its original context. The museum presents reconstructions of materials and spaces at a variety of scales. Careful detailing and material selection helps to create a clear understanding of what is original and what has been reconstructed.

The ground floor preserves the original character of the palazzo. Lighting enhances the forms and materials. The building itself becomes part of the display and is experienced in conjunction with the art. Contemporary engineering systems for comfort and preservation are well integrated into the design. Only the fire stairs stand out as a clear exterior modification.

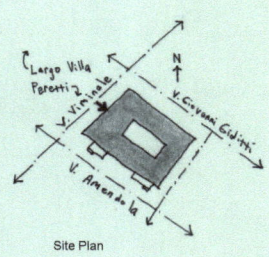
Site Plan

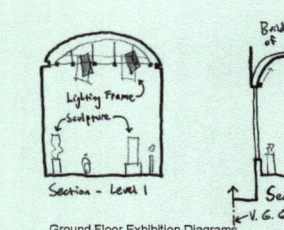
Ground Floor Exhibition Diagrams
Building becomes part of the display.

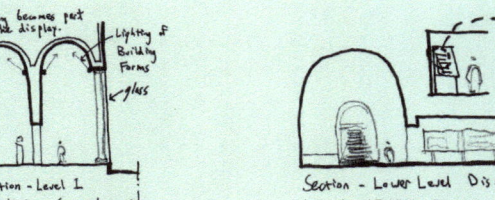
Lower Level Exhibition Diagrams
Small scale reconstructions.

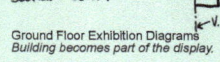
Level One Exhibition Diagrams

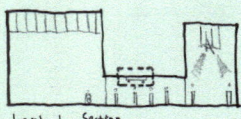
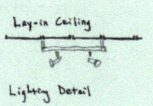

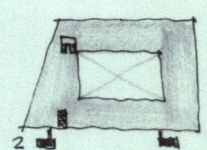
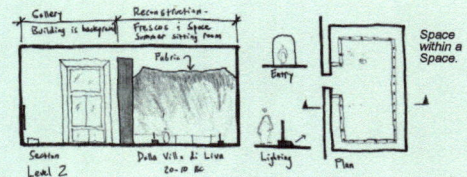

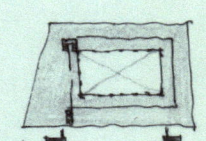
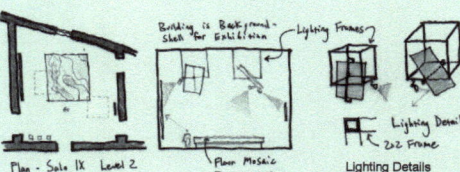

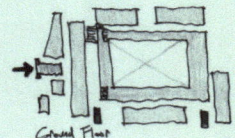
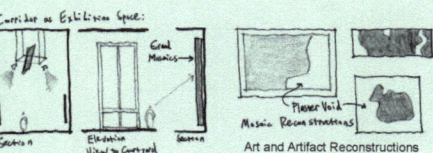

Plan Diagrams

Level Two Exhibition Diagrams

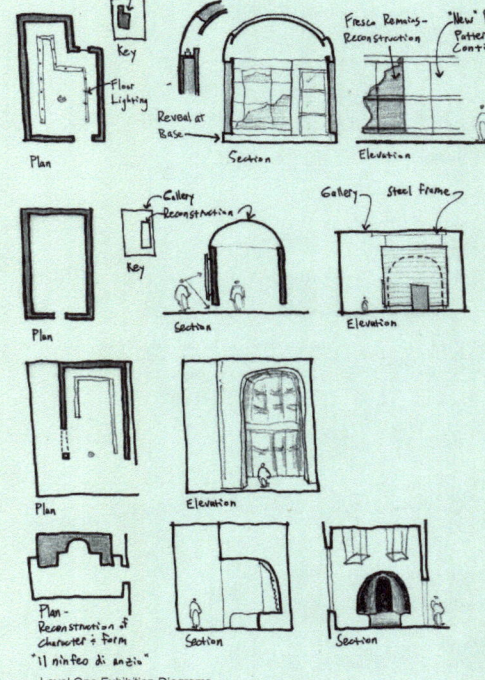
Level One Exhibition Diagrams
Reconstruction are the focus: Building is background.

SITE 18

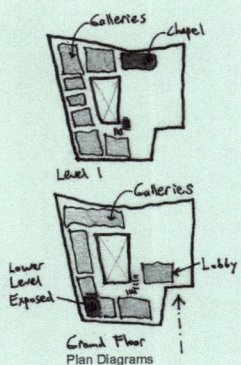
Plan Diagrams

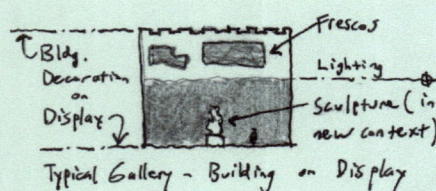
Typical Gallery – Building on Display

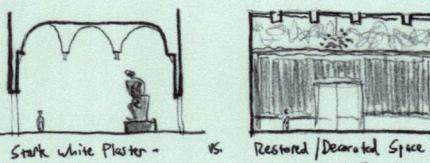
Stark White Plaster – Forms & Sculpture vs. Restored/Decorated Space – Materials & Finishes

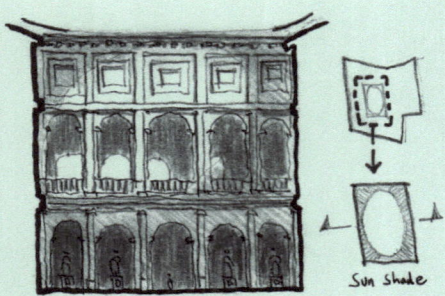
Courtyard Section
Interior Courtyard is an active part of the exhibition: Building and Art.

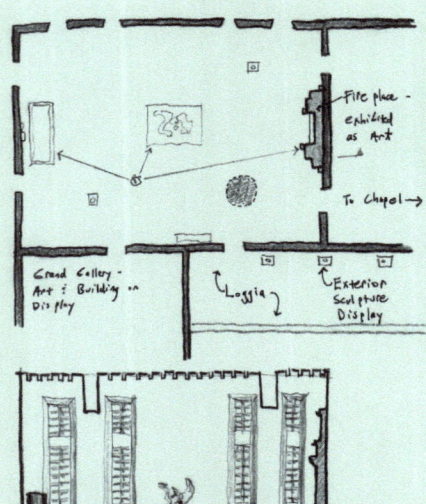
Grand Gallery Plan & Section

Gallery Ceiling Plan

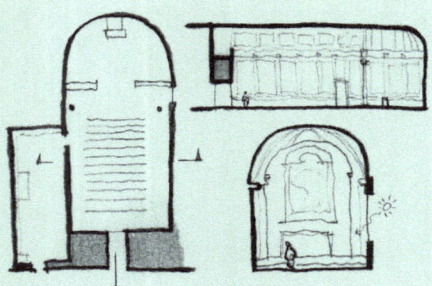
Chapel Plan and Section
The chapel now functions as a gallery to display itself.

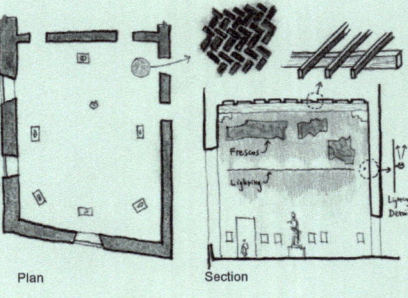
Plan Section
The building's decorative finishes are displayed in conjunction with sculpture. Careful lighting aids in display of the interior elevation.

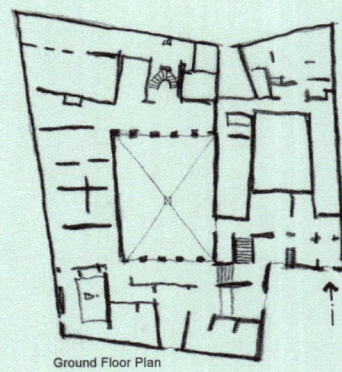
Ground Floor Plan

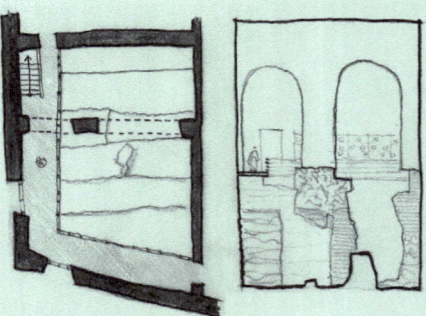
Plan & Section: Display of Excavations

Palazzo Altemps

History The Palazzo was commissioned by Pope Sixtus IV in preparation for the 1475 Jubilee. It was designed by Girolamo Riario and took the place of several medieval buildings on the site. The building later fell into disrepair and was largely uninhabited until the mid 1500s. It was then purchased and remodeled by the Altemps family according to designs by Martino Longhi the Elder, Flaminio Ponzio, and Francesco Volterra. The Chapel of Sant'Aniceto was rebuilt in the early 1700s. In 1887 the palazzo was acquired by the Vatican and used for the Pontifical College of Spain. It was purchased by the state for the Archaeology Department of Rome in 1982. It has since been restored and transformed into a museum displaying ancient sculptures.

Significance Adaptations to the Palazzo Altemps by the Vatican and the Altemps family were motivated by functional and symbolic needs—the building has a distinguished presence in an important neighborhood. Preservation was a motivating factor for the palazzo's transformation into a museum. Today, art galleries exhibit a variety of ancient works removed from their original context but showcased in this significant and dignified building. Exposed excavations add another layer of history to the site.

Site Plan

20. S. Nicolas / Roman Temples
 to Juno, Janus & Hope
21. San Clemente
22. Crypta Balbi
23. Museum of the Walls

PART III
Detail Scale Projects

S. Nicolas / Roman Temples of Juno, Janus & Hope

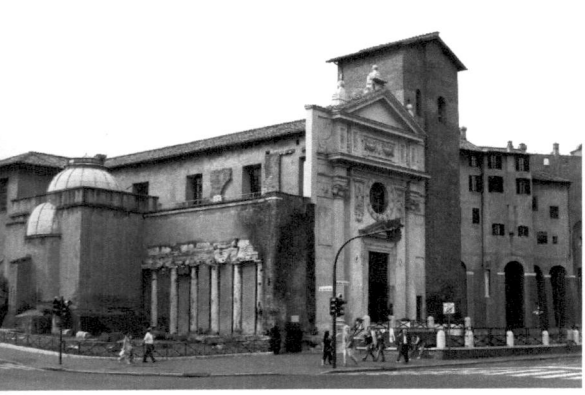

History In the 6th century BCE a fruit and vegetable market occupied the site that is now home to San Nicola in Carcere. A temple to Janus was constructed on the site around 260 BCE, followed by a temple to Hope in 254 BCE and a temple to Juno in 195 BCE. These temples were eventually abandoned. The church of San Nicola in Carcere was constructed on top of the ruins of the ancient temples in the 11th or 12th century. The face of the church dates from 1599.

Significance Initial adaptations of the structures on the site were motivated by functional demands, but ultimately helped to preserve the histories of the richly layered site. The ancient temples can be experienced from the lower levels of the church, which provides a sense of the scale of the ancient structures. Parts of the Roman structures are integrated into later wall construction almost as a form of decoration. In the lower levels visitors can observe the ways in which structural re-use and preservation intersect at the site. Moreover, the diverse palette of materials ranges from rough stone to the smooth base of the temple of Janus. The church of San Nicola, with its symbolic reclamation and adaptation of the ruins anchors the site.

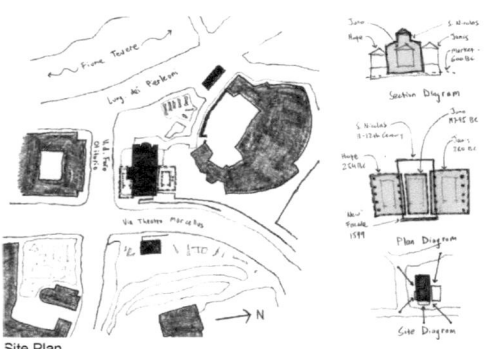

Site Plan

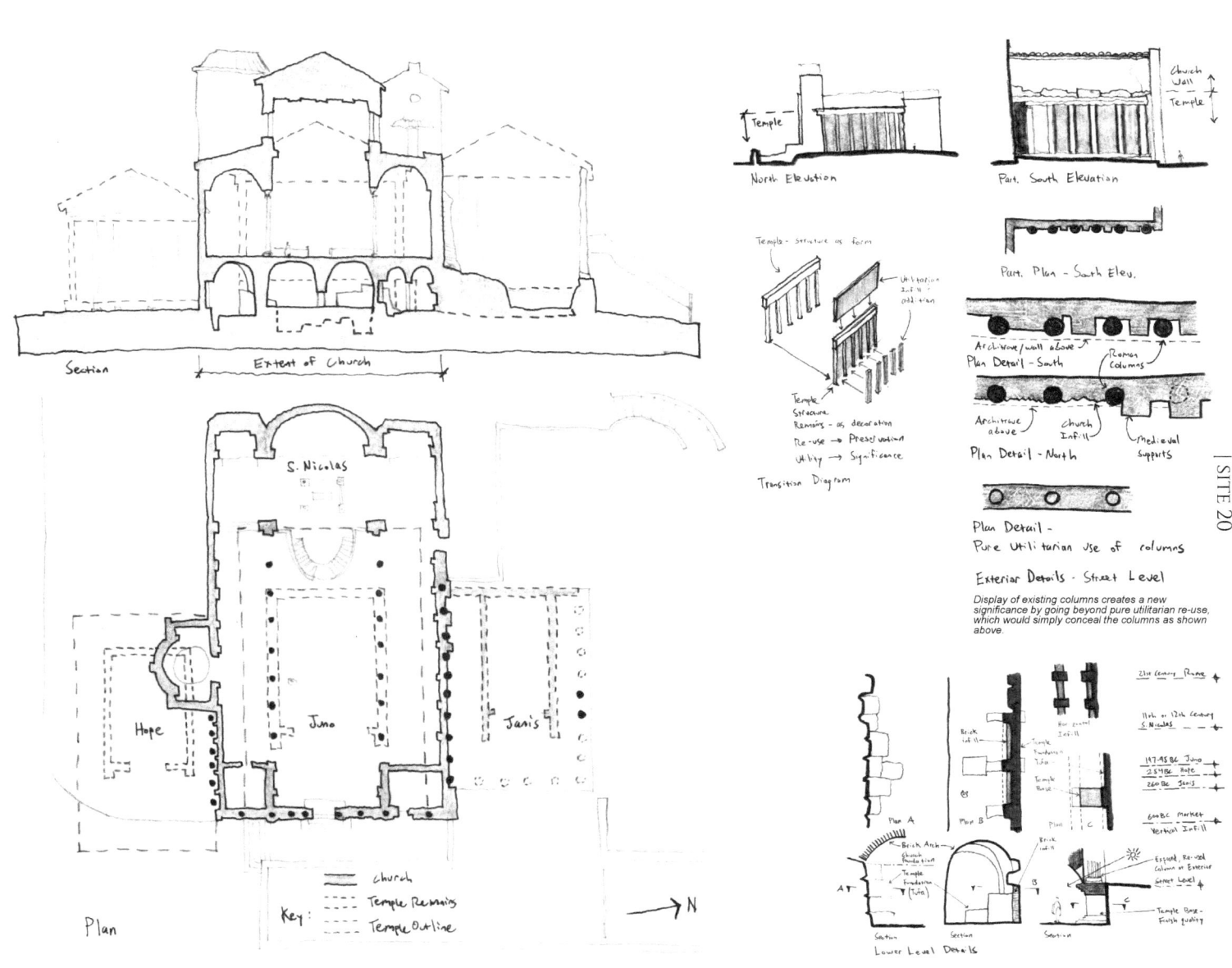

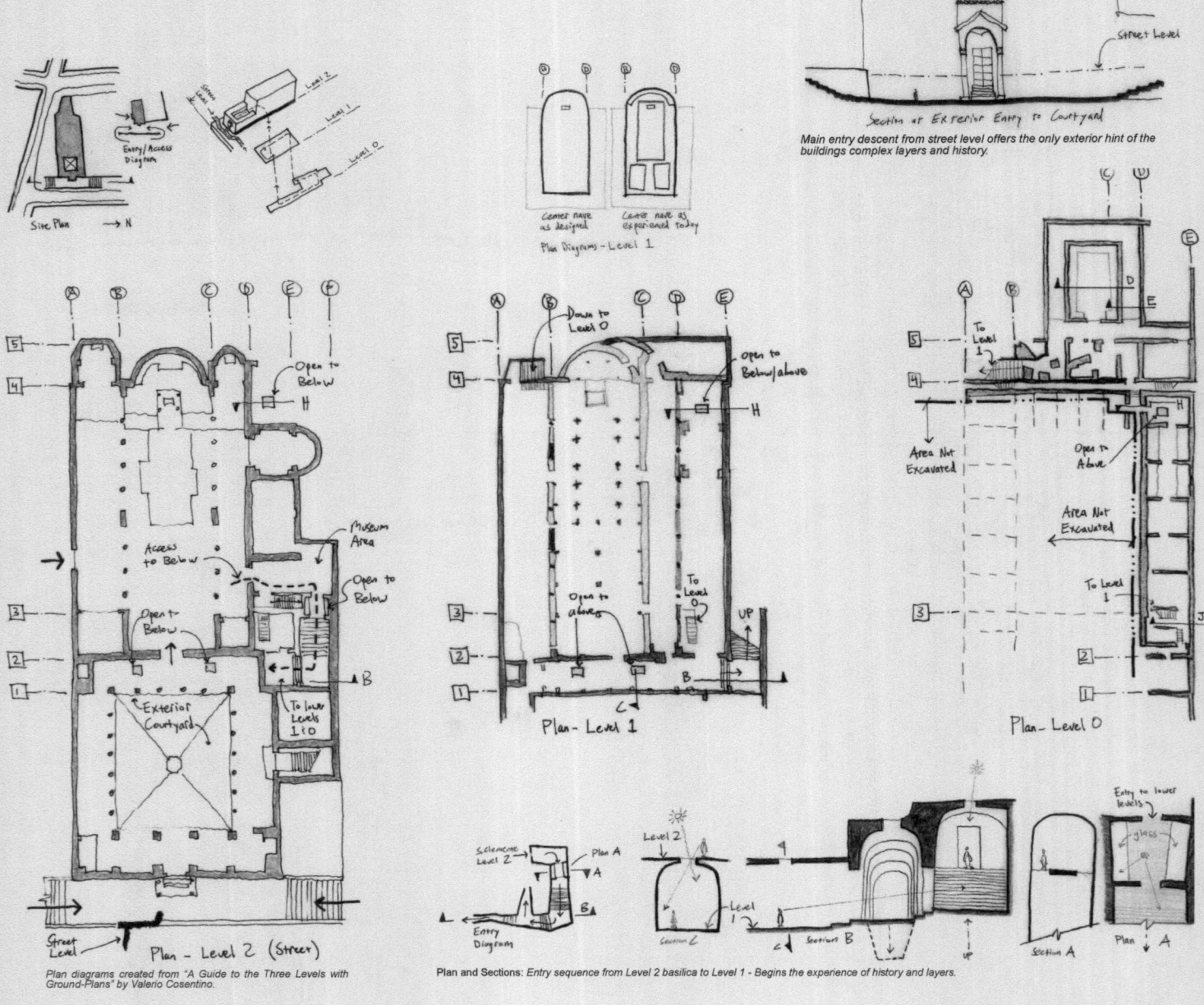

Main entry descent from street level offers the only exterior hint of the buildings complex layers and history.

Plan diagrams created from "A Guide to the Three Levels with Ground-Plans" by Valerio Cosentino.

Plan and Sections: Entry sequence from Level 2 basilica to Level 1 - Begins the experience of history and layers.

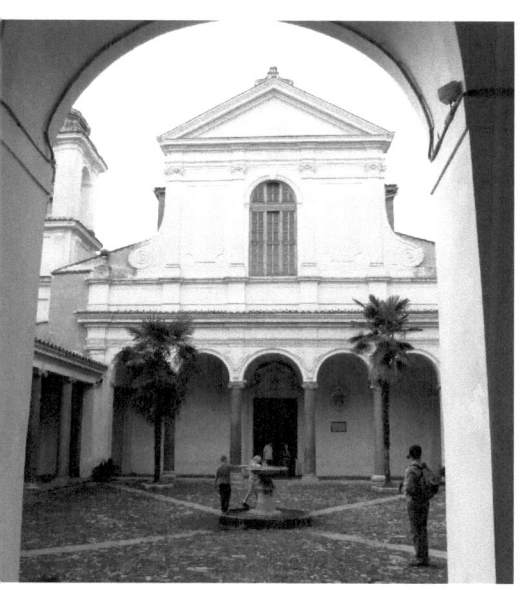

San Clemente

History In the first century CE, a Roman residence with a grotto-nymphaeum structure was located on the site of the present day San Clemente. Beginning in the third century CE a Mithraeum, or Roman worship site, was built and over the following two centuries, reconstructed before ultimately being destroyed. The first Christian Basilica of San Clemente was in the late fourth or fifth century on top of earlier structures. In the 12th century a new basilica was constructed by filling in lower level spaces, and by re-using and extending walls of the earlier basilica. Additions and decorative changes were made from the 12th century through the 19th century. The lower levels were first excavated from 1858-70. In 1980 the site underwent restoration and was transformed into a museum, which showcases the layers of Rome's history.

Significance San Clemente is one of the best examples of the ways in which sites in the city have been transformed over millennia and yet continue to be actively used today. The Church remains in use and the museum function ensures active appreciation for the site. The horizontal layers of history are well displayed as visitors move down through the site, providing a sectional history of the city. An ancient Roman worship space, for example, is preserved beneath the Christian basilica. A variety of construction materials and methods are showcased throughout the site, illustrating the complexity of layering.

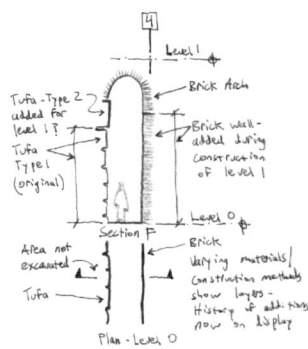
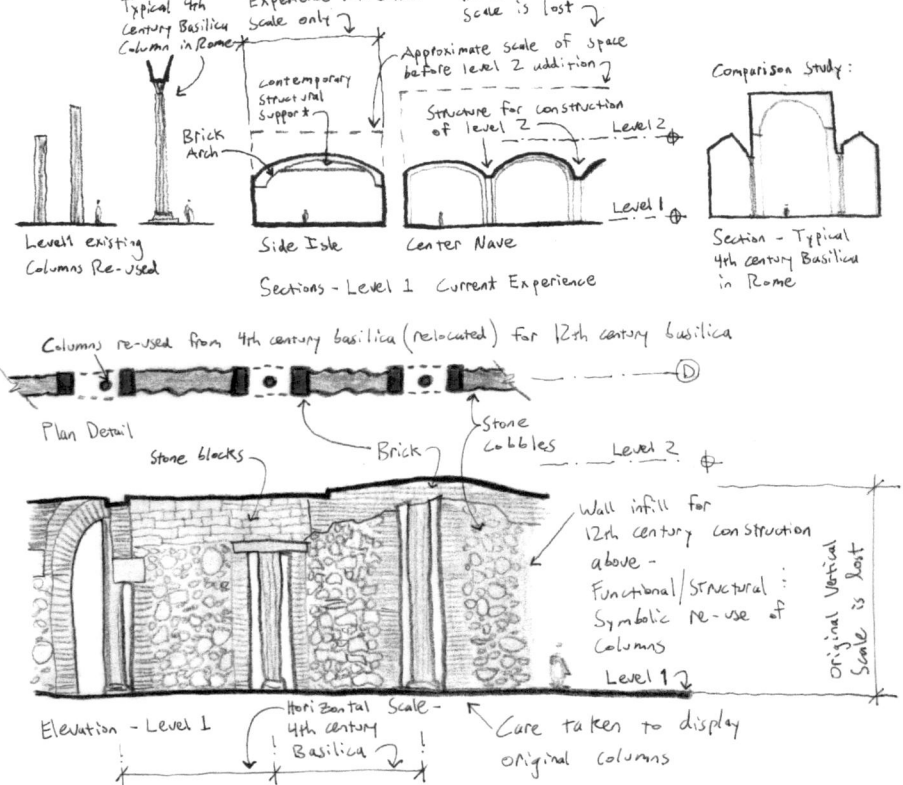

Display of existing columns creates a new significance by going beyond purely utilitarian re-use. They are detailed as separate objects and also provide an understanding of the character and scale of the original basilica as shown in the section diagrams above.

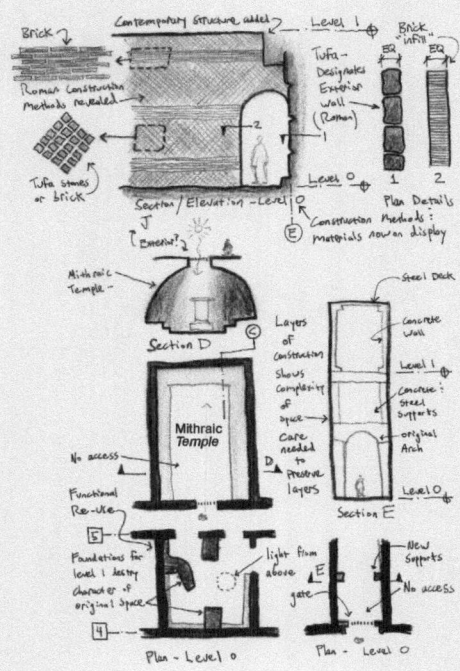
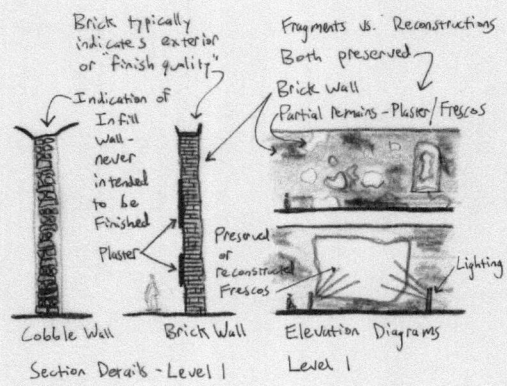
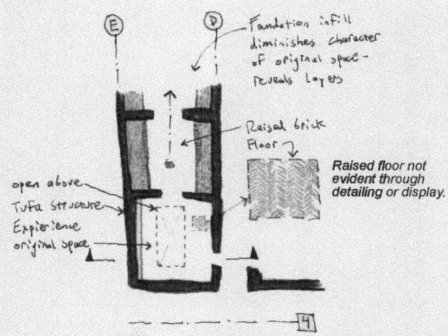

The visitor first experiences the scale of the original Roman space and then proceeds to the next room, where the size is diminished because of the new foundation infill added during the construction of the basilica above.

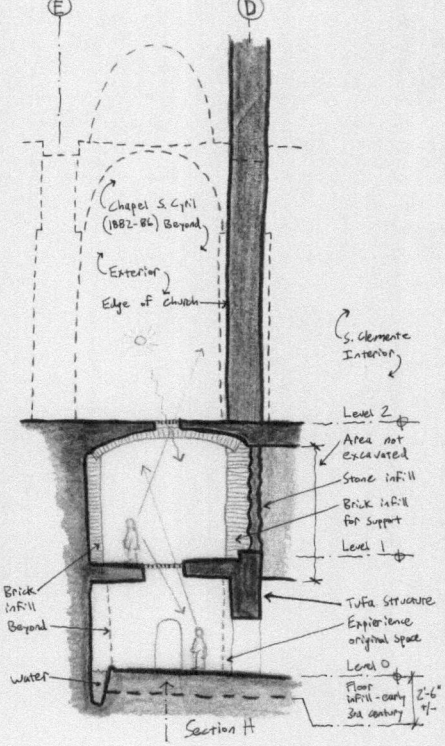

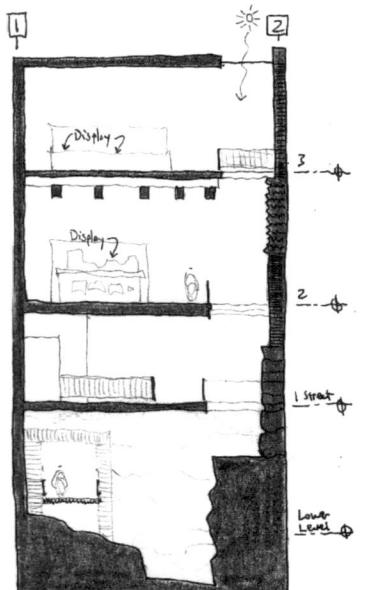

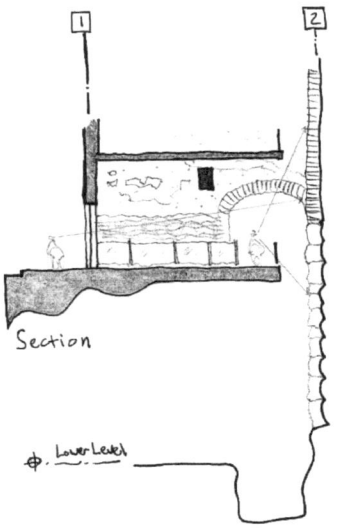

Section

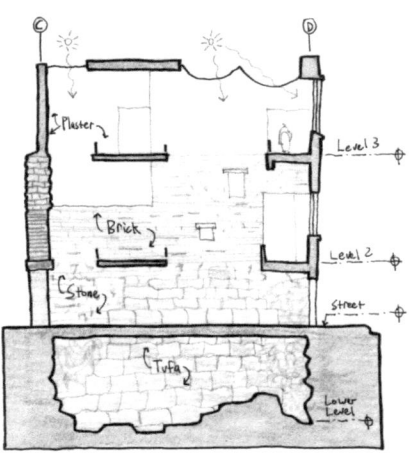

One's experience begins on the street through a visual connection to the ruins and exposed layers. This section shows the extent of one's initial interior experience. Multiple layers and construction types are gradually exposed.

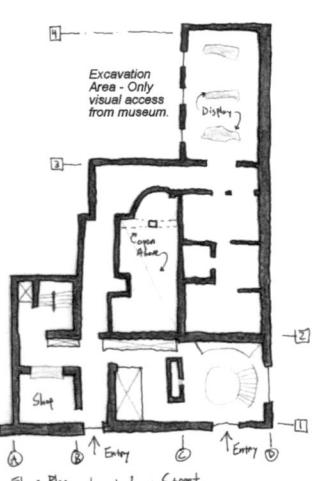

Floor Plan - Level 1 - Street

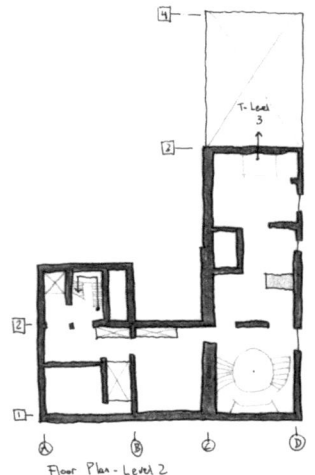

Floor Plan - Level 2

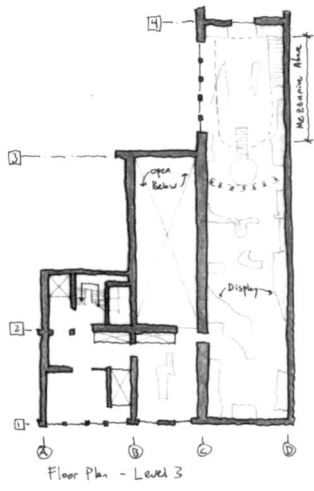

Floor Plan - Level 3

Crypta Balbi

History The Theater of Lucius Cornelius Balbus, which included a Crypta, was constructed on the site around 13 BCE. The theater and Crypta were later integrated into medieval and Renaissance buildings on the site including the convent of Santa Caterina dei Funari. Ruins and artifacts from the ancient construction were discovered during excavations in 1981. A museum was opened in 2001 in order to preserve and display the buildings and artifacts of the site.

Significance The present museum serves to both reuse and preserve the layered history of the site. In this way the museum adds a new layer and function to the site's long and evolving history. The building both serves as an exhibition space and is itself part of what is being exhibited. The new construction is clearly differentiated from existing structures through the use of contemporary materials and detailing. This clarity and sensitivity enhances the overall experience through contrast.

Site Plan: *Relationship to Ancient roman Ruins*

Section Diagram

Floor Plan - Lower Level

Experience in plan is disjunctive. The building's display of layers is predominately experienced in section. Multiple floor openings and reference points aid in a clear understanding of the complex history.

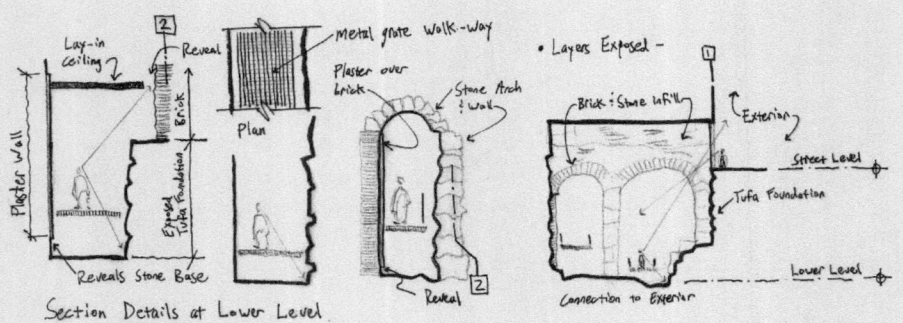

Metal grate walkways hover above the varying lower level floor line and allow observation with minimal disruption of new materials. Lower level ruins glow at night and are visible from the street.

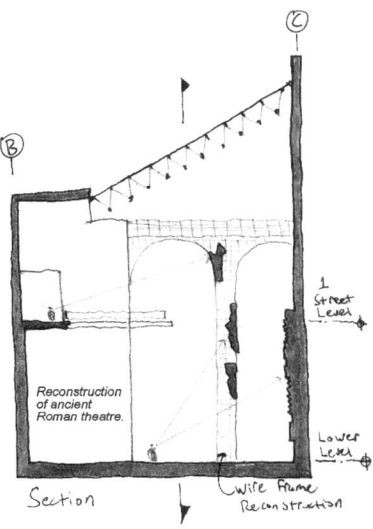

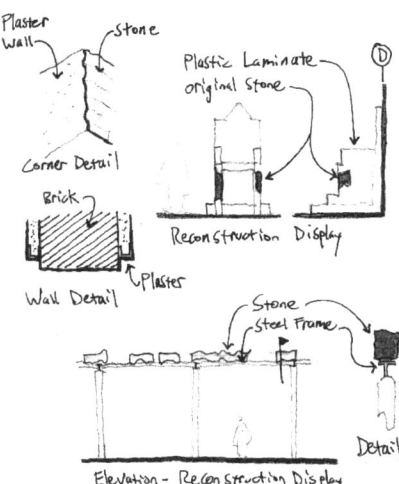

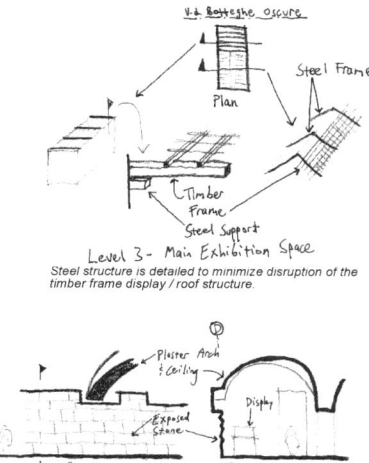

Level 3 – Main Exhibition Space
Steel structure is detailed to minimize disruption of the timber frame display / roof structure.

Level 2 Details: Medieval space and construction revealed.

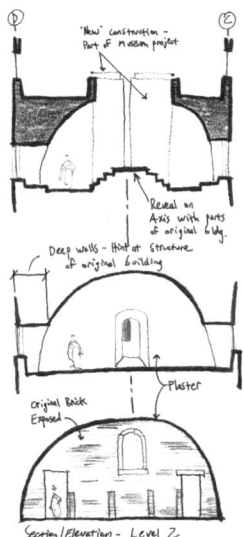

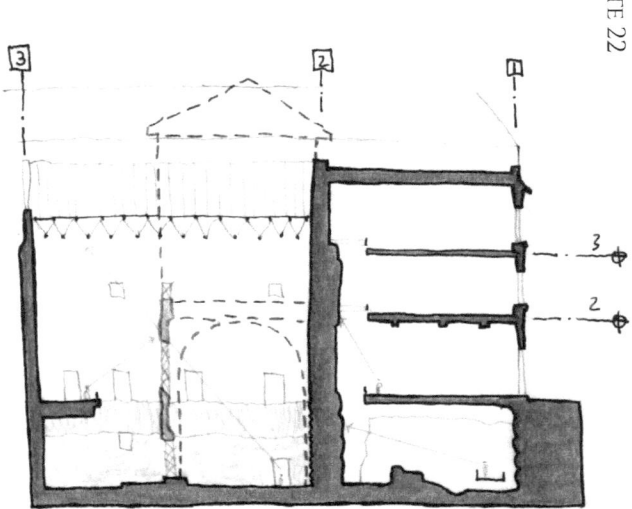

Section showing wire frame reconstruction of ancient Roman theatre combined with layered elevation of medieval and renaissance wall constructions. Interior wood ceiling serves as function and display. Lighting focuses on displaying the building. Mechanical equipment is well concealed.

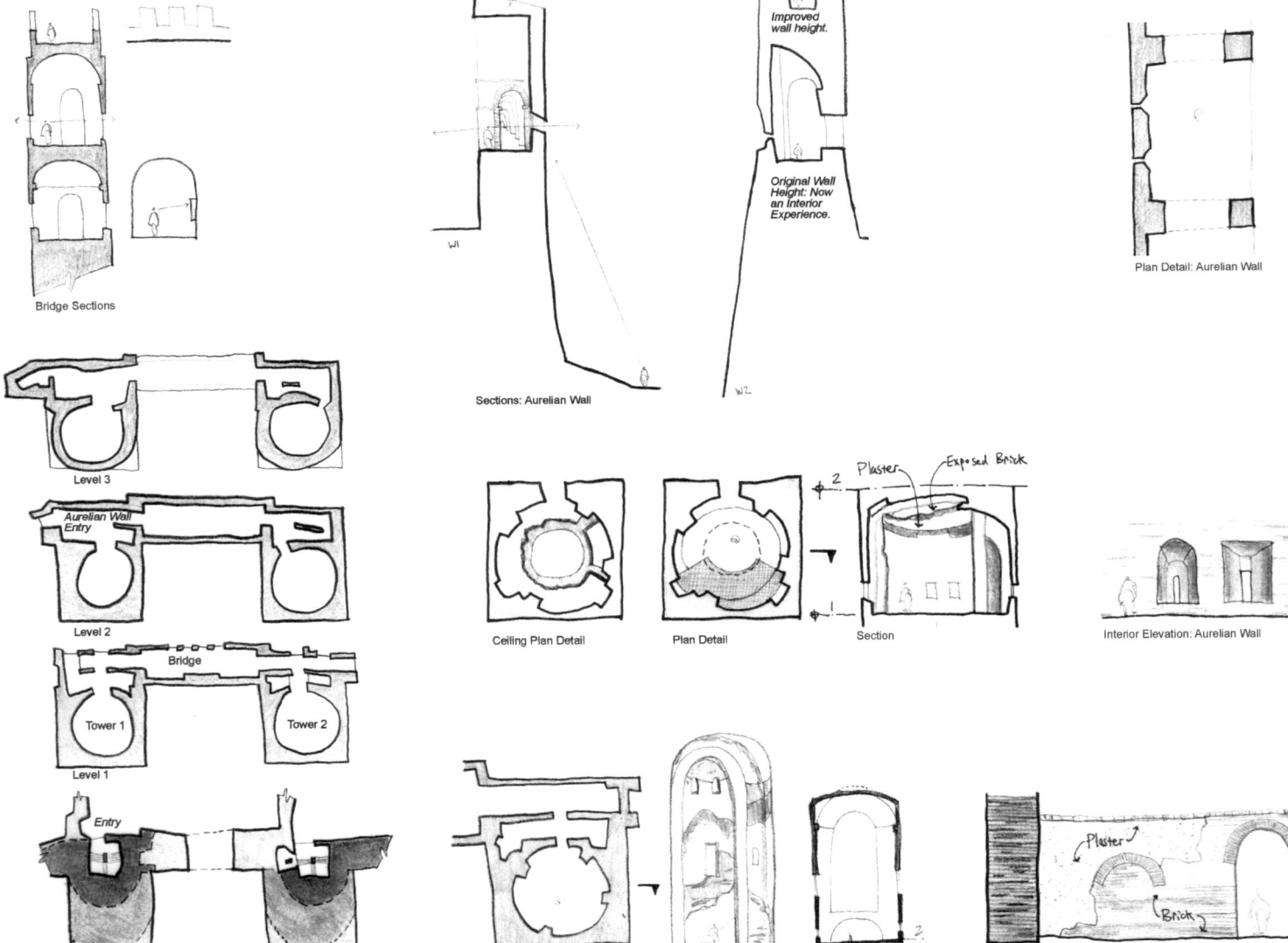

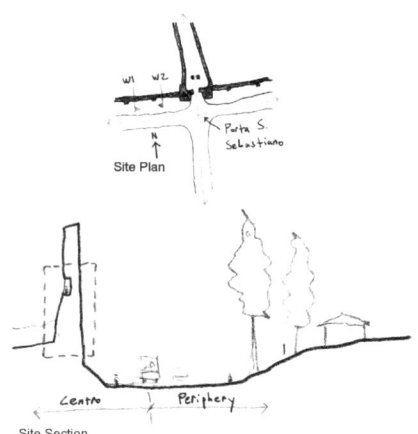

Site Plan

Site Section

Museum of the Walls

History The Aurelian Wall was commissioned in 270 CE by the Emperor Aurelian to defend Rome from the Goths. One of the original gates, Porta Appia, consisted of two round towers approximately the same height as the wall with two arched openings. The wall was later rebuilt and improved under Emperor Honorius around 401 CE. New larger towers were constructed around the earlier ones. Subsequent modifications included adding square bastions to enclose the circular towers and aid in correcting foundation problems. The arched entry was also reconstructed. In 1990, the gate was transformed into a museum dedicated to the history of the walls.

Significance The walls were originally intended to help defend the city and, on a symbolic level, to communicate power. Adaptations and modifications were largely motivated by utilitarian concerns but the structure continues to define the core of the city, the boundary of Roma centro. Moreover, the gates continue to serve as symbolic portals to the city. The museum provides access to one of the best preserved portions of the wall. Contemporary functions are minimal and the layers of gate modifications are clearly presented and preserved. The towers and bridges are now used as gallery space but the building itself remains the primary focus of the museum.

www.ingramcontent.com/pod-product-compliance
Lightning Source LLC
Chambersburg PA
CBHW051027180526
45172CB00002B/496